Giuseppe ● _Penone_

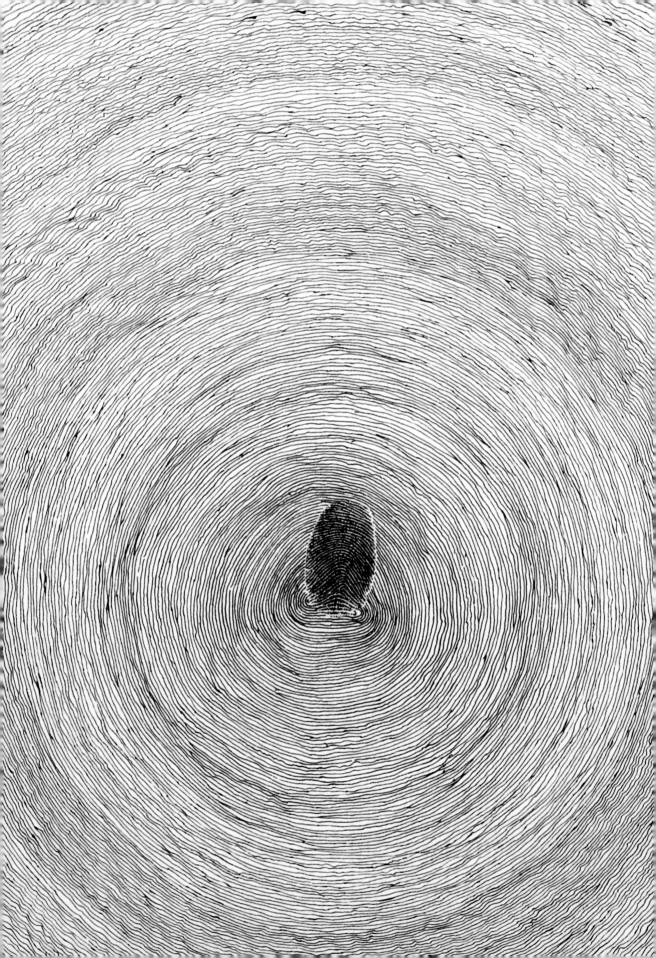

PROPAGAZIONI

GIUSEPPE PENONE AT SÈVRES

GIULIO DALVIT AND XAVIER F. SALOMON

THE FRICK COLLECTION
IN ASSOCIATION WITH D GILES LIMITED

This catalogue is published on the occasion of *Propagazioni: Giuseppe Penone at Sèvres*, an exhibition on view at Frick Madison, the temporary home of The Frick Collection, from March 17, 2022, to August 28, 2022.

Principal support for *Propagazioni: Giuseppe Penone at Sèvres* is provided by Gagosian. Additional funding is generously provided by Agnes Gund, Jane Richards, Kathleen Feldstein, and an anonymous gift.

First published in 2022 by The Frick Collection
1 East 70th Street
New York, NY 10021
www.frick.org
Michaelyn Mitchell, Editor in Chief
Christopher Snow Hopkins, Assistant Editor

In association with GILES
An imprint of D Giles Limited
66 High Street
Lewes, BN7 1XG, UK
gilesltd.com

Designed by McCall Associates, New York
Typeset in Theinhardt
Printed and bound in the United States

Cover: Detail of Giuseppe Penone, *Propagazione di Sèvres—mignolo destro* (Sèvres Propagation—right little finger), 2013 (p. 52)
Frontispiece: Detail of Giuseppe Penone, *Propagazione di Sèvres—indice destro* (Sèvres Propagation—right index finger), 2013 (p. 46)
Page 6: Detail of Giuseppe Penone, *Propagazione di Sèvres—pollice destro* (Sèvres Propagation—right thumb), 2013 (p. 44)
Page 8: Detail of Giuseppe Penone, *Propagazione di Sèvres—oro* (Sèvres Propagation—gold), 2013 (p. 68)
Pages 16, 40–41: Detail of Giuseppe Penone, *Propagazione di Sèvres—anulare destro* (Sèvres Propagation—right ring finger), 2013 (p. 50)
Pages 42–43, 54–55, 67–67: Installation views of *Propagazioni: Giuseppe Penone at Sèvres*
Page 70: Detail of Giuseppe Penone, *Propagazione di Sèvres—pollice sinistro* (Sèvres Propagation—left thumb), 2013 (p. 57)

A CIP catalogue record for this book is available from the Library of Congress.

ISBN: 978-1-913875-25-1

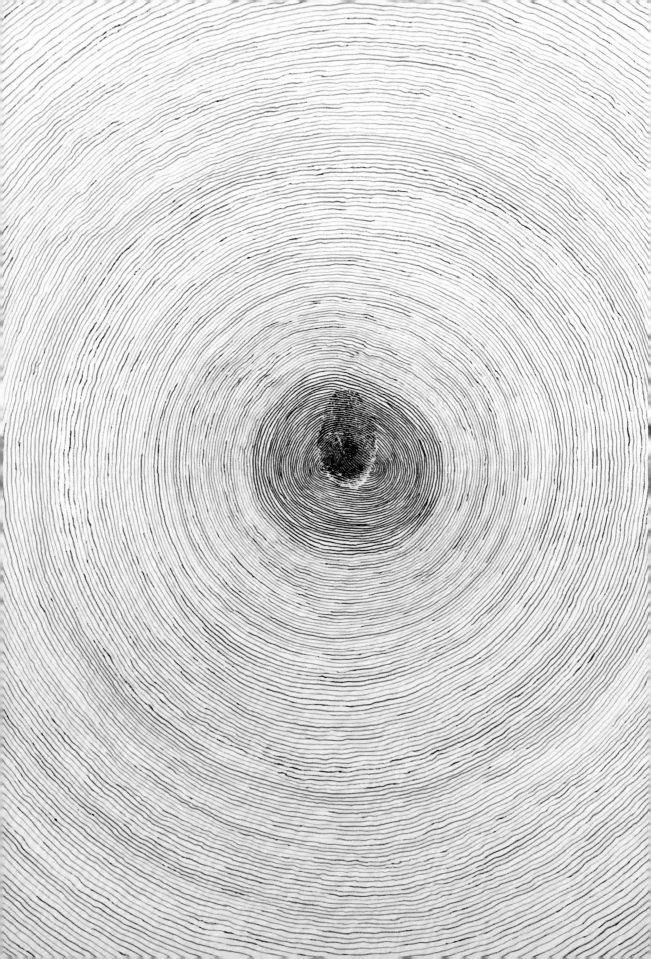

DIRECTOR'S PREFACE AND ACKNOWLEDGMENTS

IAN WARDROPPER

Anna-Maria and Stephen Kellen Director
The Frick Collection

The Frick's temporary installation of works by the renowned Italian artist Giuseppe Penone comprises eleven exquisite porcelain disks that Penone made during his 2013 collaboration with the Sèvres manufactory, the influential porcelain factory founded in the eighteenth century. A continuation of his *Propagazioni* (Propagations) series, begun in 1995, which includes various media, each disk bears the imprint of one of the artist's fingertips. One of them is in gold, its imprint a variation on the artist's index finger. Never before presented to the public, the installation of the disks in a gallery adjacent to the Frick's early Italian paintings on gold grounds and the porcelain room kindles a rich artistic dialogue with both porcelain and gold. Following on recent exhibitions by Arlene Shechet and Edmund de Waal, this is the third installation by a contemporary artist working in porcelain that engages with the museum's works of art from earlier periods.

A major figure in the Arte Povera movement of the late 1960s, Penone is known for his exploration of the relationship between art and the natural world in a body of work that includes sculpture, performance, works on paper, and even garden design. His first works in porcelain, the eleven disks presented here draw attention to the moment of touch—the convergence of surface and skin—that underpins so much of his work. They are also among the largest pieces of porcelain ever produced at Sèvres. We are delighted to be presenting these contemplative works as our first exhibition at Frick Madison, our temporary home while the Frick mansion is undergoing renovation.

First and foremost, our gratitude goes to Giuseppe Penone, both for his extraordinary body of work and for being so generous with his time in working with us on this installation. We want to acknowledge Giulio Dalvit, the Frick's Assistant Curator of Sculpture, who curated the exhibition, wrote this publication's elucidating principal essay, and worked in close dialogue with the artist. Thanks also go to Xavier F. Salomon, Deputy Director and Peter Jay Sharp Chief Curator, for his insightful introduction locating Penone's *Propagazioni* in the context of European porcelain production. Others whose work we would like to acknowledge include Tia Chapman, Joseph Coscia Jr., Allison Galea, Lisa Goble, Joseph Godla, Caitlin Henningsen, Anita Jorgensen, Adrienne Lei, Rebecca Leonard, Genevra LeVoci, Alexis Light, Gianna Puzzo, Heidi Rosenau, and Stephen Saitas. The Frick's Editor in Chief, Michaelyn Mitchell, oversaw the production of this elegant catalogue designed by McCall Associates and, with Assistant Editor Christopher Snow Hopkins, edited the text. In Penone's studio, we would like to acknowledge Dina Carrara, Federica Grosso, and Ruggero Penone.

Finally, we are very grateful to Gagosian, in particular Pepi Marchetti Franchi, for providing the principal support for *Propagazioni: Giuseppe Penone at Sèvres*, as well as to Agnes Gund, Jane Richards, Kathleen Feldstein, and an anonymous donor.

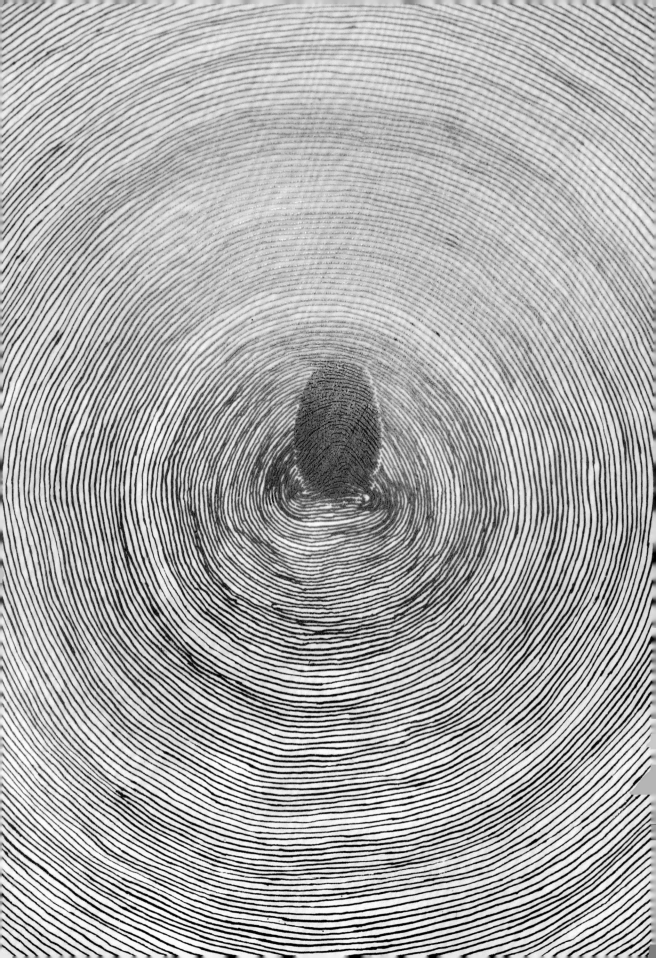

"BUT THERE ON THE SHINING SHIELD": GIUSEPPE PENONE'S *PROPAGAZIONI* AT THE FRICK

XAVIER F. SALOMON

She looked over his shoulder
 For vines and olive trees,
Marble well-governed cities
 And ships upon untamed seas,
But there on the shining metal
 His hands had put instead
An artificial wilderness
 And a sky like lead.

—W. H. Auden, "The Shield of Achilles," 1952

"I tell you that in this province, in a city called Tiungiu, are made porcelain bowls—large and small, the most beautiful you can imagine, made nowhere other than in this city; from there they are carried throughout the world."[1] Written in a Genoese prison cell in 1298, this passage from Marco Polo's *Description of the World* is the first reference to porcelain in the western world, and it initiated what would become a deep and longstanding appreciation for porcelain in Europe. Polo was clearly quite taken by the glistening white porcelain, a material at once durable and fragile. He named it *pourcelaine*, after a small shell with a similar surface, the *Monetaria moneta* (commonly known as the money cowry), which until the late nineteenth century was used as a medium for the exchange of goods in parts of Asia, Africa, and the Pacific. A small, white, nondescript vase in the treasury of the Basilica of St. Mark's in Venice (fig. 1) is said to be the first piece of porcelain to have been brought to Europe—by Marco Polo himself.

For more than four hundred years, from the thirteenth century until the early eighteenth, Europeans imported porcelain ("white gold") from China and later also from Japan; and due to the great cost, it became a luxury item. Europeans were intrigued by the fact that porcelain was made with earth materials. We now know that porcelain is produced from the extremely high-temperature firing of three main quarried ingredients—kaolin, feldspar, and quartz—which transforms them into a material of extraordinary color, translucency, and endurance. The discovery in Europe of this porcelain formula was made in the early eighteenth century in Dresden, at the Saxon court, by alchemists whose activities echoed the ultimate act of creation in the Judeo-Christian tradition. The opening of the Bible states, "In the beginning God created the heaven and the earth. And the earth was without form, and void" (Genesis 1:1–2). As God populates the earth with flora and fauna, he concludes his creation of the world with the creation of man: "And the Lord God formed man of the dust of the ground, and breathed into his nostrils the breath of life; and man became a living soul" (Genesis 2:7).

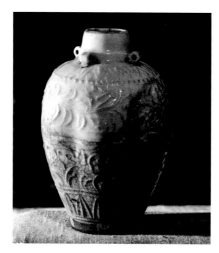

Fig. 1. Chinese. *Vase*, Song dynasty, ca. AD 960–1279. Porcelain, h. 4¾ in. (12.1 cm). Treasury, Basilica of St. Mark's, Venice

Giuseppe Penone's work is associated with the act of creation and with the earth and its elements. For five decades, the artist's practice has focused on human action and its repercussions on a material and, more broadly, on nature. In 1969, he began to carve industrial beams, archaeologically revealing the tree within, following the concentric rings of the tree itself from which the beam had been mechanically produced. In so doing, he has created an extraordinary body of work that meditates on and investigates the soul of sculpture: touch and gesture, time and space. The concentric rings of trees, as well as the ripples produced by a foreign body coming into contact with the surface of water, have inspired some of Penone's most iconic works. About 1995, the artist initiated a series of drawings on paper known as *Propagazioni* (Propagations), which revolved around the sense of touch. A fingerprint in black paint provides the epicenter of sophisticated concentric lines that spiral across the white sheet of paper. The contact of a finger on the paper (a material created out of wood pulp and water) provides the starting point for an exploration of both time and space, inherently similar to the rings that record the life of a tree or the fleeting ripple that traces the contact between a human being and water. Over time, the *Propagazioni* expanded to other surfaces, such as the walls of Rome's Complesso Monumentale di San Michele a Ripa (a goverment complex that was once a juvenile detention center) in November 2009 (fig. 2). Most recently, *Propagazioni* have extended to porcelain.

During the past decade, The Frick Collection has organized a number of monographic exhibitions dedicated to its ceramics holdings, from French faience to eighteenth-century European porcelain from Germany (Meissen), Austria (Du Paquier), and France (Sèvres). On two occasions, the Frick has invited contemporary artists—Arlene Shechet and Edmund de Waal—to dialogue with the museum's porcelains. This resulted in the exhibitions *Porcelain, No Simple Matter: Arlene Shechet and the Arnhold Collection* (2016) and *Elective Affinities: Edmund de Waal at The Frick Collection* (2019). The first exhibition at Frick Madison, the temporary home of The Frick Collection in the building designed by Marcel Breuer for the Whitney Museum of American Art, follows in the footsteps of these projects and is dedicated to the porcelain *Propagazioni* that Penone created in 2013 at the Sèvres manufactory, one of Europe's foremost porcelain factories. This is the first time these extraordinary pieces have been exhibited to the public. Ten large, round, convex disks, or shields, in white porcelain—one for each finger of Penone's hands—were molded and fired in single pieces and decorated in black paint with *Propagazioni*. An eleventh disk was decorated in the same manner but in gold.

In the early twentieth century, collectors in the United States were particularly interested in eighteenth-century French porcelain. In 1916, Henry Clay Frick acquired a three-piece set of Sèvres porcelain from the collection of the Earl of Dudley (fig. 3).[2] Included are two vases *à oreilles* (with ears) and a central potpourri vase *à vaisseau* (in the shape of a ship). The set was probably made about 1759, but the central element followed a design established in 1757 by Jean-Claude Duplessis, then the artistic director at Sèvres. Used to contain dried leaves, flowers, and spices to perfume a room, the potpourri represents one of the principal technical achievements at the manufactory in the 1750s. Its complex form made it difficult to create, and production was limited to a small number for patrician patrons. Today, only ten of these vases *à vaisseau* survive. Each was decorated in different colors and with distinctive painted decorations. The Frick's vase, in blue, green, and gold, has birds painted by Louis-Denis Armand *l'aîné* on its front and back. Two years later, in 1918, Frick purchased another important set of Sèvres porcelain: three vases in a design known at Sèvres as *à feuillage* (with leaves) or *feuilles de mirte* (myrtle leaves) because of its naturalistic botanical decoration (fig. 4). These two sets are the Frick's foremost pieces of eighteenth-century Sèvres porcelain. Toward the end of his life, Frick acquired additional pieces from the French manufactory, and others have been added subsequently, most recently, the *Vase Japon* purchased in 2011.

By the time Penone worked at Sèvres, the manufactory had been in continuous operation for more than two hundred and sixty years. First established in Vincennes in 1745, it was moved in 1752 to Sèvres, southwest of Paris, under the auspices of Madame de Pompadour, the mistress of King Louis XV. It was created very much in the shadow of the Meissen manufactory in Saxony, fashioned to "fabricate porcelain in the manner of Meissen, that is painted and gilded with human figures" (*de fabriquer de la porcelain façon de Saxe, c'est à dire peinte et dorée à figure*).[3] However, the manufactory quickly developed distinctive designs, shapes, and decorations of its own, moving away from the model of Meissen. Over time, Sèvres produced objects that extended the boundaries

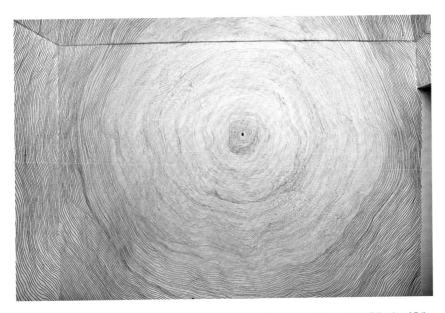

Fig. 2. Giuseppe Penone, *Propagazione*, 2009. Typographic ink and permanent ink on paper with ink on wall. Installation view of *Cella: Strutture di emarginazione e disciplinamento* (Prison Cell: Structures of Exclusion and Disciplining), Ex Carcere Minorile, Complesso Monumentale di San Michele a Ripa, Rome, November 5–23, 2009

11

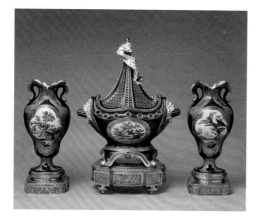

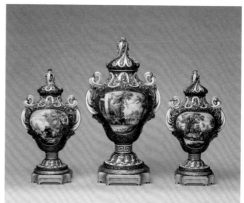

Fig. 3. Sèvres Porcelain Manufactory, *Garniture with Potpourri Vase "à Vaisseau" and Two Vases "à Oreilles,"* ca. 1759. Soft-paste porcelain, with later addition of gilt-bronze bases, 17 ½ × 14 ⅞ × 7 ½ in. (44.5 × 37.8 × 19 cm) and h. 12 ½ in. (31.8 cm), diam. 6 ⅝ in. (16.8 cm) each. The Frick Collection, New York

Fig. 4. Sèvres Porcelain Manufactory, *Garniture of Three Potpourri Vases "à Feuillage,"* ca. 1762. Soft-paste porcelain, with later addition of gilt-bronze bases, 14 ³⁄₁₆ × 8 ½ × 7 ⅛ in. (36 × 21.5 × 18 cm) and 11 × 6 ¾ × 5 ¼ in. (28 × 17 × 13.3 cm) each. The Frick Collection, New York

of technical achievement. Both the Frick's vase *à vaisseau* and Penone's *Propagazioni* are in this category of works of art, in terms of ambition and proficiency.

Before Penone started to experiment at Sèvres, the manufactory had not yet surmounted the technical challenge of producing large pieces at the scale of his eleven *Propagazioni*. In 1774, the last of Louis XV's mistresses, Madame Du Barry, purchased a small round table—known as a *guéridon*—from the *marchand-mercier* Simon-Philippe Poirier. Created by Martin Carlin and Charles-Nicolas Dodin, the table is made out of rare acajou wood, and its top is decorated with plaques of Sèvres porcelain. In the center is a large, round porcelain panel that reproduces *The Concert of the Grand Sultan*, a painting by Charles-André van Loo, and surrounding it are six decorative scenes based on paintings and drawings by Antoine Watteau (fig. 5). Decorating wooden furniture with porcelain plaques from Sèvres had become common in the 1770s, and Martin Carlin was among the most prominent furniture makers interested in this practice. In the case of the Du Barry *guéridon*, since the manufactory was not able to produce a single plaque of porcelain large enough to cover the tabletop, the surface was instead covered with a small central roundel and six surrounding scenes. Two other, almost identical, tables—probably commissioned by Poirier—were also produced by Carlin and Dodin and decorated with Sèvres porcelain.[4] One, made in 1777, was purchased by the king's younger brother, the Comte d'Artois, in December 1780 and gifted in 1784 to Elżbieta Grabowska, mistress of King Stanisław August Poniatowski of Poland. Its main scene—after Jean Raoux's *Telemachus Recounting His Adventures to Calypso*—and the six surrounding monochromatic scenes depict episodes from the life of Ulysses's son, Telemachus (fig. 6). Another *guéridon*, also created in 1777, was a royal gift in 1780, through Charles Gravier, Comte de Vergennes, to Maria Luisa of Parma, Princess of Asturias and future queen of Spain (fig. 7). Its decoration centers on another Greek mythological figure: Achilles. The principal scene—*Achilles Discovered by Ulysses among the Daughters of Lycomedes*—is surrounded by six monochromatic plaques representing narratives from Achilles's life.

The idea of surrounding a large roundel, or shield, with narratives—as with the two Sèvres *guéridons* that show episodes from Homer's two epic poems, *The Iliad* and *The Odyssey*—may have come from one of the most celebrated passages in *The Iliad*. In Book 18, Thetis, Achilles's mother, commissions the god Hephaestus to fashion a large metal shield decorated in gold and silver:

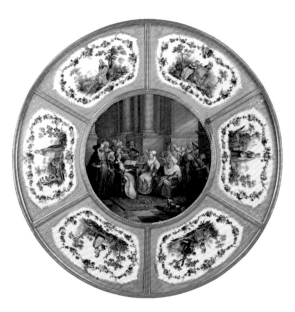

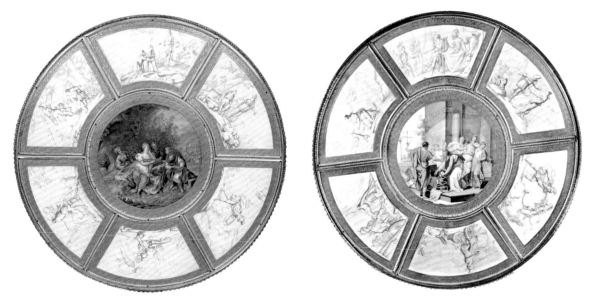

Fig. 5. Martin Carlin and Charles Nicolas Dodin, *Guéridon*, 1774. Wood, gilt bronze, and Sèvres porcelain, diam. 31½ in. (80 cm). Musée du Louvre, Paris

Fig. 6. Martin Carlin and Charles Nicolas Dodin, *Guéridon*, 1777. Wood, gilt bronze, and Sèvres porcelain, diam. 31½ in. (80 cm). Royal Castle, Warsaw

Fig. 7. Martin Carlin and Charles Nicolas Dodin, *Guéridon*, 1777. Wood, gilt bronze, and Sèvres porcelain, diam. 31½ in. (80 cm). Royal Palace, Madrid

13

And the bellows, all twenty, blew on the crucibles,
breathing with all degrees of shooting, fiery heat
as the god hurried on—a blast for the heavy work,
a quick breath for the light, all precisely gauged
to the god of fire's wish and the pace of the work in hand.
Bronze he flung in the blaze, tough, durable bronze
and tin and priceless gold and silver.[5]

On the surface of the shield, Hephaestus represented a microcosm of human civilization, beginning with the earth itself, the sky, and celestial bodies: "there he made the earth and there the sky and the sea / and the inexhaustible blazing sun and the moon rounding full / and there the constellations."[6] In its sweeping and majestic writing, Homer's description is akin to the opening of Genesis and the account of the creation of the world. The portrayal of the shield of Achilles in *The Iliad* provided the model for the description of a second shield in another ancient epic poem: the shield commissioned by Venus from Vulcan (the Roman version of Hephaestus) for her son Aeneas in Book 8 of Virgil's *Aeneid*. While the shield of Achilles represents images of an idyllic and timeless world, the shield of Aeneas looks ahead to the future and represents episodes from the early history of Rome, the city and empire created by Aeneas's descendants. In looking at the past and future, the shields of Greek and Latin literature deal with both space and time, the main concerns of Penone's *Propagazioni*.

While at the Frick, Penone's *Propagazioni* will interact with the Frick's holdings of porcelain, both European and Asian, and especially with pieces of eighteenth-century Sèvres. In doing so, a conversation between past and present and a meditation on the possibilities of materials and art will be established. The imprint of Penone's work on the manufactory at Sèvres allows us to consider important questions around the nature of porcelain in Europe, its technique and production, as well as broader issues related to creation and human imprint on the natural world of the planet we inhabit and on its materials.

NOTES

1. Polo 2016, 142.

2. For the Frick's holdings of Sèvres porcelain, see Pope and Brunet 1974.

3. Pope and Brunet 1974, 185. For the early history of Sèvres, see ibid., 183–97.

4. For the three tables, see Rochebrune 2002; M. S. García Fernández in Madrid 2007, 284–85, no. 73; and Grątkowska-Ratyńska 2009.

5. Homer 1990, 482–83.

6. Homer 1990, 483.

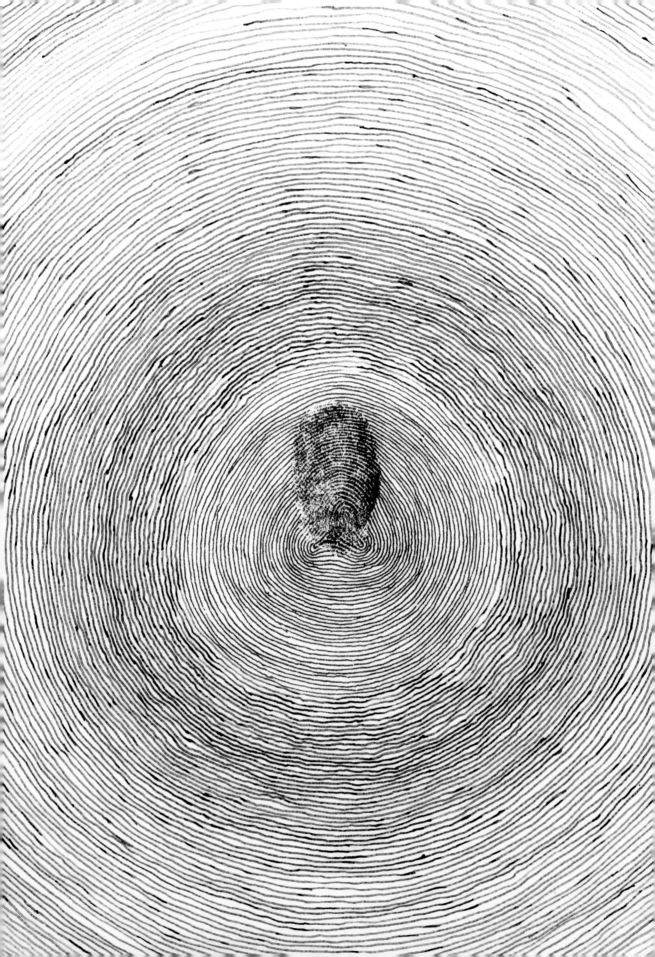

PROPAGAZIONI IN PORCELAIN: RIPPLES OF THOUGHT AFTER A CONVERSATION WITH GIUSEPPE PENONE

GIULIO DALVIT

In Virginia Woolf's *The Years*, one of Eleanor's streams of consciousness is triggered by her chinaware. "Take this cup for instance; she held it out in front of her. What was it made of? Atoms? And what were atoms, and how did they stick together? The smooth hard surface of the china with its red flowers seemed to her for a second a marvellous mystery."[1]

Eleanor's fascination lasted for only a second, but Europeans had been obsessed with questions like hers for nearly five hundred years. What is porcelain made of? How is it made? What is its chemical composition? As mentioned in Xavier F. Salomon's introduction, porcelain probably first appeared in the West in the thirteenth century, when it was recorded in Marco Polo's *Description of the World*, but it remained a mystery for Europeans until the eighteenth century. European rulers spent large amounts of money in their efforts to unlock its secrets and then to start producing it locally. Ever since Johann Friedrich Böttger's first successful imitation of kaolin-based Asian porcelain in Dresden in 1708, European kings and princes exhibited something of a porcelain mania, one that led some to bankruptcy. The Germans even coined a specific word for this: *Porzellankrankheit* (porcelain illness).

Hard yet thin, translucent, smooth, and white, porcelain has often taken its admirers on a journey into a material obsession. Be it Eleanor holding out her china in front of her or Augustus the Strong establishing the Meissen manufactory, the fascination with porcelain has to do, mostly, with its materiality. Indeed, the feeling of porcelain on the skin is believed by many to be encoded in its very name: *porcellani* in the Venetian vernacular (and many similar-sounding words in other languages) are cowrie shells, which feel as smooth on the skin as porcelain does.

Like Eleanor, the Italian artist Giuseppe Penone also looks at porcelain, first and foremost, as *matter*. The word *matter* is synonymous with both *material* and *problem*, but *materia*, the Italian word for *matter*, is not endowed with this double meaning. In Penone's native language, *materia* is the antonym of *ragionamento* (reasoning). Penone creates work that straddles this antinomy between form and content, and so, in many ways, English serves the purpose of commenting on Penone's art quite well. But since Penone is rightfully celebrated for his eloquent and lyrical writings, a translation of the artist's own words from a conversation held in his studio in Turin in March 2021 has been incorporated into this essay. Nothing short of a textual inlay, the following pages tackle the body of work presented at Frick Madison from different angles, aiming to account for the philosophical complexity underpinning its formal simplicity.

Fig. 8. Vitrine with a terracotta mannequin made by Penone's grandfather, Giuseppe Cerrina, as displayed in Penone's aunt's shop in Mondovì, in the Piedmont region, ca. 1960.

In 2013, Penone was invited to collaborate with the Sèvres manufactory, where he made works in porcelain for the first time. Among the objects produced there are the eleven hard-paste porcelain disks on view for the first time at Frick Madison (pp. 42–43, 54–55, 66–67). At the center of each disk is a fingerprint—one for each of the artist's ten fingers—constituting a center from which countless thin lines are drawn in metal oxide paint extending across the surface concentrically. The eleventh disk is painted in gold and is a variation on the artist's right index finger (p. 69). The title for these eleven disks, *Propagazioni* (Propagations), is shared with a series of works produced by Penone since 1995 in different media, most of which replicate the same visual pattern of a fingerprint encircled by concentric lines. All made by hand, *Propagazioni* require a making process that stretches over long periods of time, thus implicitly making some claim for close and prolonged viewing to trace the artist's propagating lines.

When I was contacted by David Caméo [then director of the Sèvres Porcelain Manufactory], *I did not immediately accept his invitation because I did not know what kind of work I could produce at Sèvres. And I was very busy at the time. Also, I had never worked with porcelain before. As a young boy, aged seventeen or eighteen, I went to Albisola* [a seaside town on the Ligurian coast] *to try and understand what ceramics were. Ever since, I have made many works in clay, but I had never worked with porcelain.*

In addition to working as a lathe turner in various brickworks, Penone's grandfather, Giuseppe Cerrina, was an amateur figurative sculptor (fig. 8). Penone initially followed in his grandfather's footsteps, making naturalistic portraits of members of his family. Along with his trip in 1964 to Florence and Rome, where he grew particularly fond of the work of Botticelli, Masaccio, and Verrocchio, he stayed also in Albisola, then a thriving artistic center that specialized in ceramics,

with artists such as Piero Manzoni and Lucio Fontana displaying their work there on a number of occasions. This is how Penone reminisced about Lucio Fontana's studio in Albisola in a text of 2008:

> Some parts of sculptures lay, abandoned, in a ceramics workshop in Albisola amid a heap of crockery, vases and objects that emerged broken from the kiln. I still clearly remember that material, made organic and living by the gestures of the sculptor, which sprang forth from the flat space of the clay. Undefined structures in relief suggested images in boundless space created by the suggestion of the work in just a few centimetres. Reliefs of gestures pierced, with their dark silvery colour, the dark transparency of the bluish glass. The forms seemed suspended in the mass of colour used as material and all the parts merged, erasing the boundaries between sculpture and painting. Colour emerged spontaneous from the material as a structural part of the work. It was extraordinary the contrast with the nearby objects where instead colour was a part added to the clay form, a garment. Some gestures like lumps of cosmos appeared in the space created by the action of man and by the primordial action of the fire of the kiln that, like a small matrix, had developed the embryos of the work. Only the defects and ruptures diminished the enchantment of that Spatial Concept. And this is how at the age of eighteen [in 1965] I encountered the work of Lucio Fontana.[2]

For me, back then, the problem was the adherence of matter to the body, which was a consequence of the 1960s views around the issue of the "minimal image" in art. We wanted to reduce language to an alphabet of primary elements; to simplify language in order to rebuild the world from scratch. Due to its relationship with the surrounding space, sculpture was a way for me to eschew the problem of representation. If you put a bottle on display, it's an object; if you draw a bottle, it's a drawing. The problem was that of reality versus representation: I wanted to intervene on reality.

This idea of reconsidering the conventions of art making was at the core of the Arte Povera movement. Despite the name "Arte Povera" [Poor Art], there were no interdictions as to the materials to use—there is no real equivalence between Arte Povera and poor materials. So, for me, the preciousness of porcelain was not a problem per se. My problem with porcelain was its decorativeness. At Sèvres, I had to find a way to make something that would not become a decorative object.

But when I actually went to see Sèvres, where I had never been before, when I saw the complexity of the manufactory and the skill of everybody who worked in it—and I mean everybody, from those who make the models to those who make the molds to those who tend the kilns to those who chose the enamels to those who paint—when I saw this complexity, this operative quality, I realized that I could do something interesting only by valuing these people's expertise. I did not want to create convoluted forms but rather wanted to find a work that could be exemplary of this expertise and history of astonishing technical achievement.

With porcelain, size matters. During the firing process in the kiln, the smallest discrepancy in thickness can lead to fractures as the porcelain cools from about 2,645 degrees Fahrenheit to 570 degrees Fahrenheit. With other types of clay, one can get away with unevenness of the surface, but that is never the case with porcelain. The grander the scale, the easier it is for a piece to break. Large porcelain objects are thus very rare and always constitute a technical tour de force. Over the centuries, collectors have proven to be as fond of the littleness of small-scale jewel-like pieces to hold in their hands as they were of the majestic scale of large objects, which were usually produced under royal patronage.

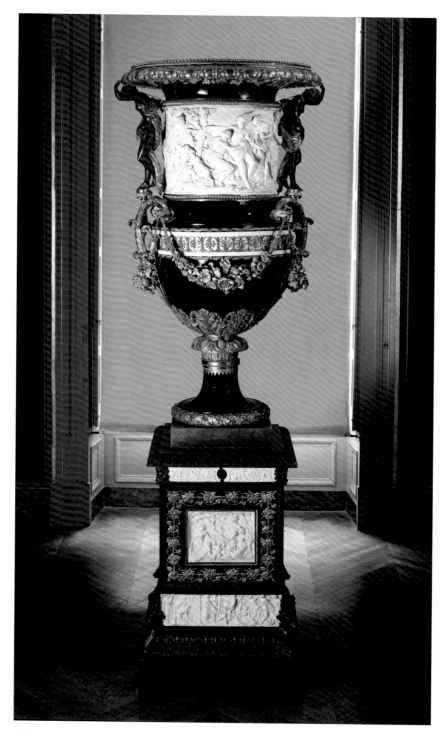

Fig. 9. Louis-Simon Boizot and Pierre-Philippe Thomire, *Vase Médicis* ("The Grand Vase"), 1783. Hard-paste porcelain and gilt bronze, 78¾ × 35⁷⁄₁₆ in. (200 × 90 cm). Musée du Louvre, Paris

Sèvres
Pollice sinistro G. Penone 2012

In particular, a French royal decree of 1784, under Louis XVI, while significantly reducing Sèvres's privileges to the advantage of non-royal manufactories and private porcelain entrepreneurs, encouraged the royal manufactory's contribution to art and national prestige by confirming Sèvres's exclusive right to the more elaborate of use-less wares. The sculptural, non-utilitarian, and gigantic *Grand Vase* (fig. 9), made in 1783, anticipated by a year, like a manifesto of sorts, the types of wares that were to become Sèvres's special province. The decree of 1784 put into words one of Sèvres's main missions since its establishment—to make technically challenging and superbly designed porcelain pieces, which, if only because of their size, could stake a claim to a place within the realm of Art with a capital *A*.

I thought that this idea of Propagazioni—*the idea of linking together the lines of a fingerprint so as to draw a circle that then propagates into space, as if it were ripples in the water or sound in the air—I thought that I could develop this idea with a porcelain object. So, my reflection on Sèvres became a dish. Despite being an object of everyday use, in many cultures, dishes are an apex of artistic expression, as they bring about many reflections on life and religion—just think of Arabic dishes with scripts from the Quran. But I decided to turn the shape of the dish upside down, from concave to convex, enlarging the dish as much as possible, in order to do justice to the technical abilities of the Sèvres workers. They told me that the maximum diameter of a disk that had to be replicated ten times was about 60 cm. We decided to add a border along the backside of the disks, which bestowed some rigidity on the work and could also be used for hanging the disks. I made a drawing for each disk (fig. 10), and then they made plaster molds, from which they made the disks by slip casting. Once they dried out, they were fired. And that was the most difficult part because they had to ensure that the surface was flawless, with no undulations. Because fluid porcelain tends to sink, they had to figure out a way to support it during firing in order to produce a convex shape. Difficult though it was, I really wanted to take away any practical aspect from the dish. Also, the drawing of the lines proved particularly difficult; a special pen had to be manufactured to distribute the paint as evenly as possible.*

There is no symbology in my dishes, but there are formal choices. I wanted a margin, of a varying width, to extend along the border of the disk because I didn't want the work to invade the space around it. I wanted to concentrate my work into a very precise geometry. In terms of the colors I used, black lines are evocative of charcoal, an organic material linked to our body in so many

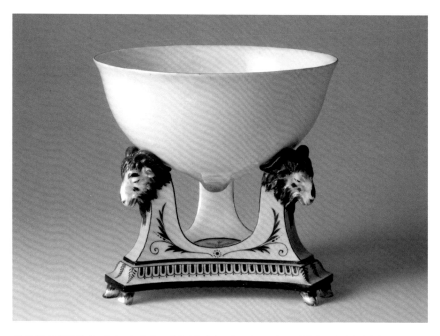

Fig. 11. Sèvres Porcelain Manufactory, Louis-Simon Boizot (design) and Jean-Jacques Lagrenée le Jeune (painting), *Bol-sein* (Bosom Bowl) or *Jatte-téton* (Nipple Cup), 1787–88. Hard-paste porcelain. 4¹⁵/₁₆ × 4¹³/₁₆ × 5¼ in. (12.5 × 12.2 × 13.3 cm). Cité de la céramique, Sèvres

ways—a material that covers, creates shadow, and is connected to the idea of painting as covering. The interaction between white and gold is typical of Egyptian art. Gold for me encapsulates the idea of light and preciousness. Its symbology crosses cultures and is associated with objects that demand preservation. And gold, together with pink and blue, is one of the colors typical of Sèvres— which I take to express light, carnality, and the absolute. At some point, I toyed with the idea of using pink for one of the disks, so as to more explicitly evoke a woman's breasts—that ancestral pull toward milk-producing breasts. It did not work visually, but this idea still permeates the disks.

One of the most astonishing objects ever to be produced at Sèvres is the so-called *Bol-sein* (Bosom Bowl) or *Jatte-téton* (Nipple Cup), a milk bowl made in 1787–88 as part of a service for the Laiterie de la Reine (the Queen's Dairy) at Rambouillet, a gift from Louis XVI to his wife, Marie Antoinette (fig. 11). Breast-shaped and naturalistically painted, the bowl rests on a classicizing tripod, creating an ensemble notable for the absence of gold. It would be held by the queen as she drank her milk, revealing more of the nipple as she turned the cup up. That Penone, while working on his disks, thought of referencing this famous design suggests that the disks made at Sèvres, geometric and abstract as they may look, should also be interpreted in relation to the human body.

At approximately 26 inches in diameter, these convex disks are larger than most known porcelain dishes. They may be the largest objects of their kind ever to be produced at Sèvres. However, approximating the traditional unit of measurement of a *braccio* (arm), Penone's disks, though large-scale, are perfectly attuned to human scale.

Given the connection between Penone's disks and the human form, it is not surprising that Sèvres workers call them *lentilles* (lenses), a shorthand name that points to a parallel with a much earlier work, considered by many to be one of the most programmatic statements of the artist's career—*Rovesciare i propri occhi* (Reversing One's Eyes) (fig. 12), a performance that consisted of

Fig. 12. Giuseppe Penone, *Rovesciare i propri occhi* (Reversing One's Eyes), 1970. Mirrored contact lenses. Photographic documentation of an action by the artist.

his wearing custom-made mirrored contact lenses. As Penone put it, in this work, "the image that the author, in representational tradition, perceives, memorizes and retransmits with the work at a subsequent time is, in this case, transmitted by the work before the author has seen it."[3] Whatever meaning one may want to attach to this work, whose conceptual implications far outweigh the economy of its making, *Rovesciare i propri occhi* deals with the eye as one of the main instruments of human perception. Like skin, lungs, eyelids, and fingernails (some of Penone's most frequently explored themes), the eye is understood by Penone as a thin, porous barrier between inside and outside. Similarly, the skin so frequently at the center of the artist's works is not so much a closed envelope that contains an organism (the limits of one's self) as a permeable boundary that opens onto the world, a locus of exchange. Drawing on the analogy between skin and eyes, Catherine de Zegher stated that *Rovesciare gli occhi* concerns an extremely small "imprint" between the eye and the world—a concept that is also visualized in two drawings by Penone at MoMA, in which the fingertips of a hand, marked by the artist's fingerprint, are encircled by the shape of an eye.[4]

A further analogy is often drawn between *Propagazioni* and the rings of trees—another focus of the artist's production since 1980, when Penone, like an archaeologist, started reversing time by carving beams down to the shape of the tree at a certain age, as marked by ring growth (fig. 13).

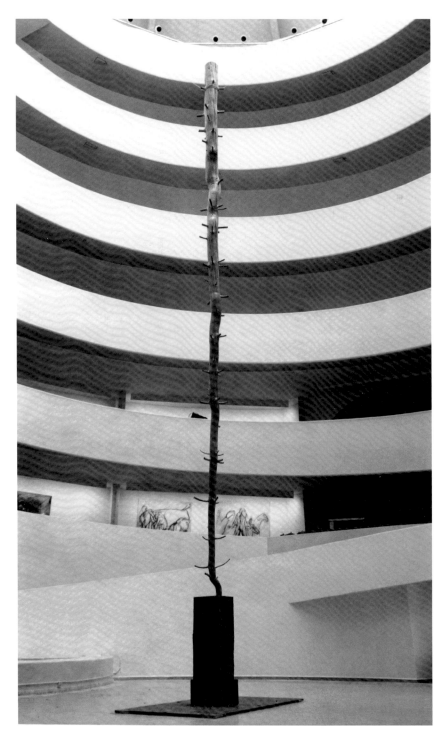

Fig. 13. Giuseppe Penone, *Albero di 12 metri* (12-Meter Tree), 1980. Larch wood, 39 ft. 4½ in. × 19¾ in. × 19¾ in. (1,200 × 50 × 50 cm).
Installation view of *Italian Art Now: An American Perspective*, Solomon R. Guggenheim Museum, New York, 1982.

Among many possible illustrations spelling out the visual (and conceptual) overlap between the spiral pattern ingrained in *Propagazioni*'s fingertips and the rings of a tree, *Nel legno* (Within the Wood) (1981) is a drawing where Penone explicitly drew tree trunks around the shape of his fingerprint.[5]

This parallel with trees, far from contradicting the close relationship between *Propagazioni* and eyes, points to a third analogy between sight and the heliotropic branches of trees. In fact, in 1994, Penone wrote that "the tree is an enormous eye made up of many smaller eyes" and that "the stretching of a branch through space in search of light has the same structure as a glance."[6] As a visual representation of this concept, *Doppio sguardo* (Double Gaze), a drawing included in the *Propagazioni* series, features two men whose gazes are transformed into tree branches.[7] More recently, *Ombra di terra* (Shadow of Earth) (fig. 14), with its terracotta fingerprint—shaped like a viewing cone—held up by tree branches, also explores the conceptual continuity (and contiguity) between imprint, eye, and tree. In many ways, the analogy of all these different forms underscores the deep interconnections among different elements of the natural world, linking the intelligence of man with the intelligence of nature, shunning any distinction of nature *versus* culture or human *versus* non-human—one of the main themes in Penone's work, which finds a parallel in Francis Hallé's many scientific publications on the intelligence of trees.

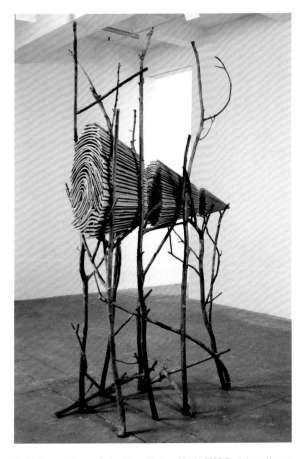

Fig. 14. Giuseppe Penone, *Ombra di terra* (Shadow of Earth), 2000. Fired clay and bronze, 9 ft. 3⁷⁄₁₆ in. × 5 ft. 3 ¾ in. × 2 ft. 9⁷⁄₈ in. (283 × 162 × 86 cm). Private collection

Against this backdrop, a thread connects many works across Penone's oeuvre with his reversed Sèvres dishes. As Tim Ingold remarked, reversal is often Penone's main strategy to alert us to the double-sided nature of the limits of our own bodies, both as barriers and points of contact with the outside world, be they skin or eyes. Furthering the significance of this gesture, Penone's reversal extends to trees, dishes, and countless other elements:

> Imagine an inside-out world, where breath solidifies but the lungs are vaporized, where the shadow is a body and the body its shadow, where entire landscapes are reflected in the balls or gathered under the lids of unseeing eyes, where trees grow from tips to roots and from the outside in … This is the world of Giuseppe Penone.[8]

A similar upturning was achieved by Piero Manzoni with his *Socle du monde* (Plinth of the World), a pedestal that, by being turned upside down, was effectively showcasing the world as a work of art. While Manzoni is invariably celebrated for the conceptual aspects of his production, Elio Grazioli has positioned him as an "artist of organic art," highlighting how the bodily connection is no less integral to his work. Looking at Manzoni's *Uovo Scultura* (Egg Sculpture) (fig. 15), with its convex shape crowned by an imprint, it is plain to see that—stripped of all the fetishistic aspect of artist veneration and the deployment of the language of miracle as a parody of consumption habits in commodity culture—Manzoni's eggs must have played a role in Penone's conception of *Propagazioni* in porcelain.

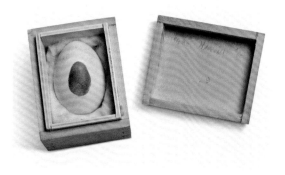

Fig. 15. Piero Manzoni, *Uovo Scultura* (Egg Sculpture), *no. 29*, 1960. Ink on egg in wooden box stuffed with cotton wool, 2¼ × 3¼ × 2 ⅝ in. (5.7 × 8.2 × 6.7 cm) [box]. Private collection

I understood Manzoni's importance from the very beginning of my career. I was interested in Manzoni even more than I was in Fontana. In Manzoni's works, there was a conceptual aspect that brought him close to Dadaism, but his action was apparently outside of the conventions of artistic language. When you see the Socle, *in an instant, it turns your perception of the world upside down. There are some very profound associations between Manzoni's work and my own. His monochromes did not interest me that much, as their problem was chiefly pictorial. But I took a great interest in all the works by him that have this organic, physiological component while also being so arresting, conceptually speaking.*

Ultimately following in Manzoni's (and Duchamp's) footsteps, Penone's art points to what already exists in reality as art—what has been termed an "anthropological formalism," that is, the ability to see the world at a distance, as an art object.[9] In this respect, Penone often references prehistoric

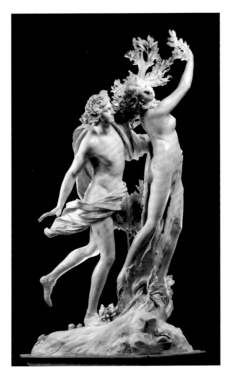

Fig. 16. Gianlorenzo Bernini, *Apollo and Daphne*, 1622–25. Carrara marble, h. 96 in. (243 cm). Galleria Borghese, Rome

Fig. 17. Giuseppe Penone pressed against one of his *Soffi*. (Breaths), 1978.

art as a source of inspiration as well as Michelangelo. In fact, while Michelangelo, adopting a Neoplatonic view of sculpture, believed his task to be the liberation of the sculpture-figure that had been trapped inside the marble block, Penone sees the block itself as sculpture. In particular, while western tradition has mostly concentrated on the modification of the marble block as sculpture, Penone's work conceptualizes mere touch as the actual medium of sculpture. Interestingly, he has often mentioned Bernini as something of a forebear of this conception, declaring a particular interest in his *Apollo and Daphne* (fig. 16). Here, not only is Penone fascinated by the possibility that the myth of Daphne transforming into a laurel tree as soon as Apollo touches her was built on the observation that laurel, normally odorless, reacts to touch by releasing its smell, but also that Bernini was seeking to explore that same "transition between realms, the confusion between body and nature" that is so frequent in Penone's own art.[10] But most important perhaps, Penone is struck by Bernini's success in producing a sculpture that pivots on *touch* as not only the climactic moment in the story of the Greek deities but the means by which he renders them in marble.

Penone's views on the limits of our own bodies, which he often reverses, also impact his conception of sculpture and vice versa. For Penone, sculpture occurs at the moment of interaction between two touching surfaces. As such, sculpture is always a reciprocal act (we can only touch while being touched, while, as Penone observes, we can see without being seen).[11] Touching the marble block modifies the surface of the block as much as it modifies our own skin: fingerprints not only mark the moment of concomitance of surface and skin but are also the trace of such sculptural acts performed by external surfaces onto our skin. "All my work is basically a reflection on sculpture," says Penone, whose ideas have vastly expanded the notion of sculpture to chart even the slightest sensory experience, in ways that are both more abstract and more literal than traditional

sculpture.[12] Even breathing, according to Penone, can be seen as an act of "automatic sculpture."[13] A part of the body that enters into a physical relationship with the surrounding elements, "each breath has in itself the beginning of fertilization, it is an element that penetrates another body and letting out the breath, the puff of air, attests to it with its form" (fig. 17);[14] performed by us on the air surrounding ourselves, and by air on our own lungs, "a breath propagates our existence in the air, insinuates itself and branches out into the wind the drawing of our lungs."[15]

Drawing attention to the extent to which we perform, and are subject to, sculptural acts, Penone alerts us to the value of sculpture as a tactile medium through which we are situated in the world. Fingerprints, he reminds us, bear the anatomical history of our interactions with the womb and are thus also a reminder that "the pressure of the air on our body is the matrix of our own skin."[16] Focusing on touch, sculpture therefore becomes the medium of sensuality par excellence, a sensuality that comes chiefly from the sculpted material. Clay, in particular, is celebrated by Penone as a "solid element that has always been tied to fluids, with its plastic characteristics reproduces in its movements the behavior of fluids."[17] Indeed, "the pleasure in shaping clay [is] witnessed by the continuous and constant production of nudes through the centuries" and also by the myth of Pygmalion, who fell in love with a sculpture he had made.[18] This myth, according to Penone, is reminiscent of how "when you produce a work with clay…when clay is damp, it is very similar to the surface of a body. There is a truly direct relationship between clay and the idea of flesh."[19]

I associate porcelain as a material with bronze, in that, after the model is made, it is given over to skilled technicians for the firing (or the casting, in the case of bronze), who are able to exploit the characteristics of the materials. Everything about porcelain happens with plaster, which is porous, hungry for water. In a way, it is like lithography, which is produced by playing with the reciprocal repellency of water and oil. I find these kinds of processes so interesting. They are simple reflections that shift your way of perceiving reality around you. What matters is the organicity of such processes. In the case of porcelain, the process entails the making of the plaster molds; the pouring of liquid porcelain into the mold (which is thus turned into a vessel or a vase of sorts); the plaster mold absorbing water, gathering clay against the internal walls of the mold-vase; the waiting for it to dry out (the cohesion between the molecules of porcelain reduces the volume of the material pressed against the walls of the vase); the opening of the mold and finding of the porcelain piece, which is then ready to be fired. If you think about it, it is sort of a magical or alchemic process. And the gestures of the Sèvres workers as they carry out these operations—filling, manipulating, emptying—are so beautiful, so fluid in their movements that it almost looks like a ballet. As you stare at the disks hanging on a wall, you cannot see these things, but they are hidden in the material history of the object. And ultimately, the object is beautiful because of the hidden beauty of the logics and the gestures by which it was created.

This attention to gesture may be an overlooked heritage of Abstract Expressionism within the Arte Povera group. For instance, Penone refers to Mario Merz as a "painter, who had a painterly conception—for him, kindling wood was like 'deaf matter' [*materia sorda*], in which he would place a neon light, as if it were a red brushstroke over a dark background."[20] Be that as it may, when considering the movements that Penone (and the Sèvres workers) engaged in to draw *Propagazioni* on porcelain (fig. 18), one cannot help noticing their bodily rotation around the object, which to some extent turns the act of drawing into an act of sculpting.

The sculpture-ness of these drawings is also evidenced by the way in which they modify the viewer's perception of the volume of the porcelain disks themselves. Like polychromy on ancient sculptures, the drawn circles, far from hovering above the surface of the porcelain disks, interact

Fig. 18. Giuseppe Penone drawing *L'impronta del disegno*
(The Imprint of Drawing), 2001. Courtesy the artist

closely with it by camouflaging its many bumps (which one could never appreciate through a photograph). The drawing thus exercises a sculptural function, while the sculpted porcelain is turned into a planar surface, onto which the drawing is executed, as if it were white paper. By surpassing the limitations of these conventionally opposing categories, *Propagazioni* turn drawing into sculpture and sculpture into drawing, so that "it is difficult to say what 'drawing' is, what 'sculpture' is . . . these are just conventions that we use only for the sake of language."[21]

What is more, the circles drawn on the surface of the disks—reminiscent, as we have seen, of the growth rings of a tree across time—make time itself visible. Unlike figurative drawings, these time-dial-like circles extend consistently around the center of the disk, and—imagining that it takes x time to draw x inches of line—they could be turned into a temporal measuring tape of sorts. Such a tape, by accounting for even the smallest hesitations of the hand, which are made visible by a sudden pooling of the paint or a thickening of the line, can almost be taken to encapsulate the "shape of time"—to evoke the title of a book by George Kubler of 1962. A diagram of the time that went into making them, *Propagazioni* are meant to "concentrate time in a space," as the artist himself puts it.[22]

By propagating in space and time through drawing, these porcelain *Propagazioni* are a powerful demonstration of the fluidity among artistic media. Penone's fluid approach to medium reflects his more general tenet that, despite our categorizations, Nature, whose clock is different from ours, is fluid within itself. In this regard, Penone has always looked at Leonardo da Vinci's works as an important source of inspiration—in particular, his sanguine drawings (fig. 19), which Penone interprets as presenting a conception of the world in which the limited human perspective

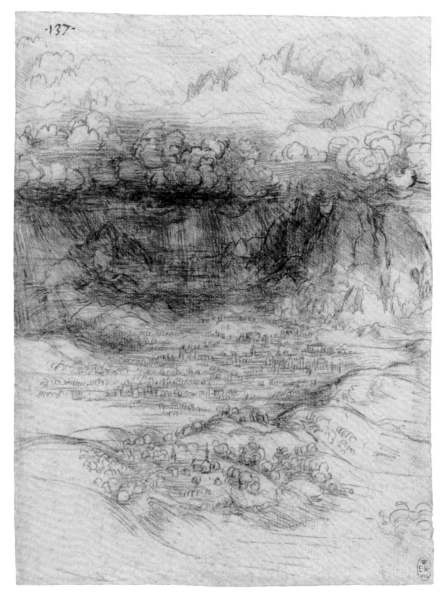

Fig. 19. Leonardo da Vinci, *A Storm over a Valley*, ca. 1506–10. Red chalk, 7⅞ × 5⅞ in. (200 × 150 mm). Royal Collection Trust, Windsor Castle

according to which materials have stable properties—say, hardness or softness—is surpassed by a conception of the world in which "mountains crumble and become sand."[23]

It is very important for me to try and understand Leonardo's thinking about Nature: the idea of a fluidity of matter, which is never the same; the correspondence of forms across different materials; the unity among different materials. Take porcelain, for instance: it is a very fragile material, like leaves can be. But ultimately, it all depends on your viewpoint. Leaves are constant, they always exist; you can mow your lawn, but it grows back…There is a persistency in fragility. In the case of porcelain, yes, it is a very fragile material. And yet, if it does not clash with other objects, it can last for millennia. You need to take care of it, but such care is somehow guaranteed by its own fragility, which demands preservation.

Imprints also demand preservation. Penone has often expressed his astonishment at the extent of society's effort to erase human imprints from the urban space—despite sanctioning fingerprints as the ultimate way to identify a person, how many times is a bar counter wiped clean of all human fingerprints on it? The ephemerality of the present, notwithstanding its importance, has thus become an increasingly more prominent theme in Penone's art, which may also have affected his choices about materials, which seem to betray a growing interest in the dialogue between firmness and volatility, heaviness and lightness.

In most cultures, verbs have tenses that help in the structuring of our thinking. The present is by far the most common of the tenses. Yet, while we are certain about the past and uncertain about the future, our present is the instant that gets continuously lost while we feel the need to affirm it—a tension that is beautifully captured by the English present, *as meaning* gift, *for it is a way to testify the presence of our existence to someone else. This was my way of reasoning in trying to make this labile imprint permanent. It was a way for me to reflect on the tension between the awareness of our vacuity and ephemerality and our need to testify our presence. And this need to mark one's presence is shared with animals and plants (think of a tree: when uprooted, it leaves the imprint of its roots in the ground).*

An imprint is the document of a real presence. On the contrary, drawing is the trace of a voluntary gesture. The two aspects often coexist in art, and they coexist in Propagazioni. *In a way,* Propagazioni *are about the contrast between the insignificant imprint of a man, which we would normally leave on a surface and erase, and the idea of turning it into an image, preserved and somewhat universal. What interested me in* Propagazioni *was precisely this coexistence of opposites—the tension between them.*

These circles drawn over the porcelain disks are a particular kind of drawing—"a drawing without worry about style, about the character of the handwriting or the manner of the artist. A drawing where the action of drawing is the subject of the work, the means indispensable to the idea, to the language, to the invention of the image."[24] Fingerprints, instead, are a conventional cultural index of individuality and uniqueness. They are used on IDs around the world; Lucio Fontana even started using them to sign his paintings in the 1950s. In the following decade, as artists sought to reduce artistic language to its minimum, fingerprints represented an interesting case of an image that is also an index. *Propagazioni* make the relationship between image and index even more inextricable by bringing together drawing (image) and imprint (index).

Image and index, however, are notions that demand definition as much as they invite disputation. First introduced into scholarship by C. S. Peirce (1839–1914), the term *index* is used to describe signs in which the signifier and the referent stand in causal relationship (e.g.,

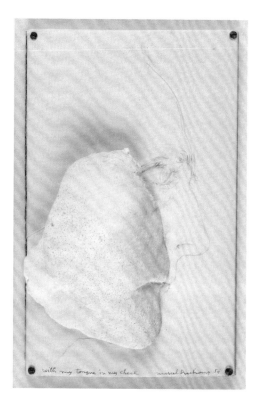

smoke and fire), like photography, according to many critics, stands in relation to reality. In her perceptive analysis of indexicality in the art of the 1970s, Rosalind Krauss pointed out that Duchamp had pioneered a critical engagement with this concept. In his *With My Tongue in My Cheek* (fig. 20), for instance, Duchamp drew his own profile; on top of the drawing, he added the area of chin and cheek, cast from his own face in plaster. By thus exposing the split between image and index, Duchamp was left, as the title of his work recites, "with [his] tongue in [his] cheek"—that is, he had lost the capacity for speech. To put it another way, Duchamp was asking whether art could ever recover from the split between image and index brought about by the advent of photography. Like Duchamp's work, but perhaps reversing its implications, Penone's *Propagazioni* explore the artistic possibilities opened up by the conceptual schism between image and index, bringing fingerprint and drawing together and thereby highlighting the productive tension that exists between the tactile and the visual. By uniting the physical space of touching with the metaphysical space of seeing, *Propagazioni* highlight the fundamental unity of image and index. Indeed, Penone has often insisted that fingerprints left on fired clay—as with, for instance, Massimiliano Soldani-Benzi's fingerprint on the *Pietà with Two Mourning Angels* at the Frick (fig. 21)—demonstrate the inseparability of image and index by advertising touch as the foundation of sculptural work.

Building on the legacy of a Renaissance attitude to the past, Penone often pursues connections that situate his work "outside of direct history,"[24] along a philosophical and artistic trajectory that extends beyond the twentieth century. One such connection could be drawn with an "emblem" (*Sinnbild*) in *Twelve Devotional Meditations on the All-Holiest Incarnation, Birth, and Youth of Jesus Christ* (fig. 22) by the seventeenth-century German writer Catharina Regina von

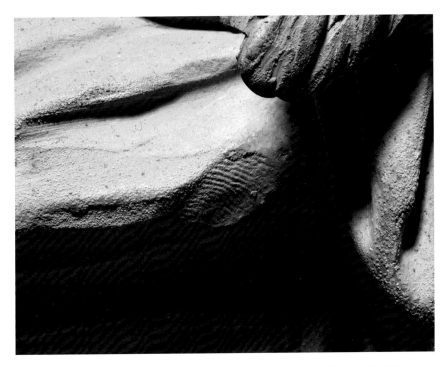

Fig. 21. Massimiliano Soldani-Benzi, *Pietà with Two Mourning Angels* (detail of the artist's fingerprint), probably 1715. Terracotta, 11⅝ × 21⅝ in. (29.5 × 54.9 cm). The Frick Collection, New York; Gift of The Quentin Foundation, 2006

Greiffenberg: an illustration, inscribed "klein doch unendlich" (small yet infinite), which refers to the mystery of Christ's incarnation, beginning with a tiny point and spiraling out to infinity to create a slightly irregular pattern, which, by evoking the rings of a tree, is especially close to Penone's *Propagazioni* on paper (fig. 23). A much stronger conceptual connection can probably be drawn between *Propagazioni* and an object that has traditionally collapsed the distinction between image and index, namely the Shroud of Turin, where Penone lives and works. Although the Shroud (like the Veil of Veronica) has been experienced by viewers and conceptualized by intellectuals in different ways over the centuries, the tension between the indexical aspect of the linen, understood as a supernatural consequence of Christ's touch, and the possibility of projecting an image on (or from) it, has always been a key aspect of its power as a relic.

Inherent to the Shroud, the tension between touching and seeing, image and index, is made most explicit in an engraving by Claude Mellan, an artist very close to the Barberini family and thus very close to Bernini (fig. 24). Here, the face of Christ emerges from the sudarium as a consequence of the thinning and thickening of one uninterrupted line spiraling over the plate. Seeing Penone's porcelain disks next to the print triggers a number of reflections on print as a medium of touch, negotiating between sculpture (plate) and drawing (paper). What is more, it becomes clear that Mellan's spiraling line was probably also meant to evoke a fingerprint, significantly centered on top of Christ's nose, that is, the area protruding farthest from the face and best suited to receiving the touch of a finger. (Importantly, in many medieval statues, the True Image of Christ is sometimes projected in high relief over the Veronica.) Conversely, a comparison of these two works facilitates an understanding of Penone's work from a broadly religious point of view. Are the artist's upside-down dishes somehow vessels of a twenty-first-century religiosity?

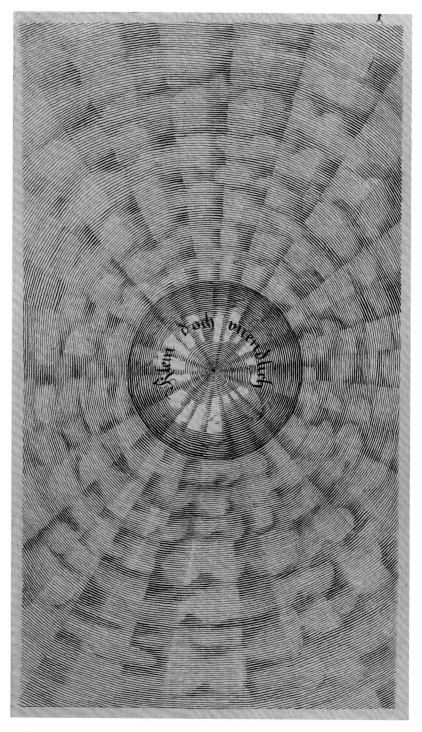

Fig. 22. Unidentified artist, emblem from Catharina Regina von Greiffenberg, *Der allerheiligsten Menschwerdung, Geburt und Jugend Jesu Christi Zwölf Andächtige Betrachtungen* (Twelve Devotional Meditations on the All-Holiest Incarnation, Birth, and Youth of Jesus Christ) (Nuremberg, 1678). Etching and engraving, 5½ × 3⅛ in. (14 × 7.9 cm). Herzog August Bibliothek Wolfenbüttel (Th 1058)

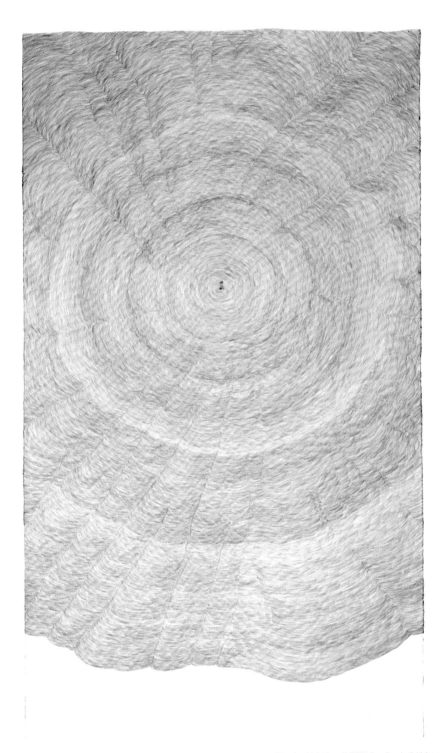

Fig. 23. Giuseppe Penone, *L'impronta del disegno (indice destro)* (The Imprint of Drawing [right finger]), 2001. Pencil and print ink on paper mounted on canvas, 6 ft. 6¾ in. × 3 ft. 11¼ in. (200 × 120 cm). Private collection

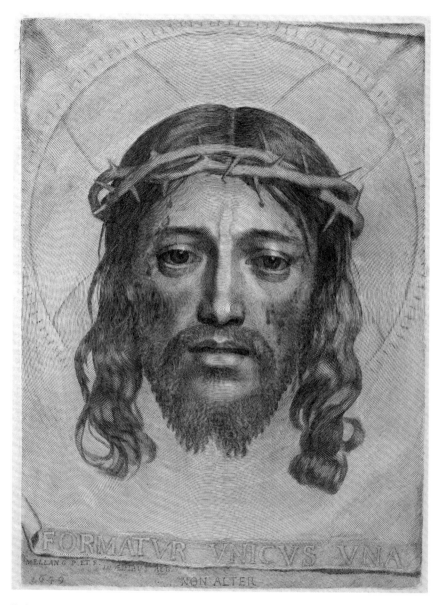

Fig. 24. Claude Mellan, *Face of Christ on St. Veronica's Veil*, 1649. Engraving (second state of two), plate 16¹⁵⁄₁₆ × 12³⁄₈ in. (43 × 31.5 cm), sheet 18⅛ × 13¹¹⁄₁₆ in. (46 × 34.8 cm). Metropolitan Museum of Art, New York; Purchase, The Elisha Whittelsey Collection, The Elisha Whittelsey Fund, 1969

Intriguingly, Mellan claimed for himself an almost divine "golden eye" (*oeil d'or*)—an eye capable of drawing a perfect circle and finding its center as accurately as with a compass. Reversing the traditional anecdote of Giotto, who was allegedly able to draw a perfect circle, Mellan, once the circle had been drawn, could find its center (which probably reflects a seventeenth-century preoccupation with the demise of geocentrism). At the center of Penone's golden *lentille* (p. 69) is neither God nor Christ: there is *touch*, whose propagation coincides with the sphere of the world as we can know it, sculpt it, and are sculpted by it. Though anthropocentric, Penone's porcelain *Propagazioni* draw attention to the degree of mental activity involved in the apparently involuntary gestures of marking, seeing, and touching—activities through which we can define ourselves but solely in relation to others and to Nature, forging an "aesthetic of reciprocity" that borders on a religious belief.[25]

I could have chosen to make square porcelain plates. I did not and not only because I started from the idea of the dish but also because circularity is organic to the universe. If, when working, one focuses only on form, the risk is to produce a work that is only made of its form—it may be pleasing, surprising, but it ultimately coincides with its form. When a work's form follows the logic of an idea, there is continuity among idea, matter, and execution. Inevitably, when you work with matter, you work with divinity, not least because materials are alive, have their own vitality and intelligence. As an artist, I do not want to force a form into the matter, I want to provide matter with its form.

Understanding reality through sculpture allows Penone to forge connections with objects made at different times and places. By letting the material speak for itself, while at the same time addressing foundational problems around art and identity, the self and other, his work transcends cultural contexts and tends toward cultural non-specificity. Ultimately, Penone's visually unassuming yet conceptually dense porcelain *Propagazioni* are works of both here and there, the past and the present, tradition and modernity. And that is why Frick Madison is the perfect place to showcase them.

NOTES

In addition to those thanked in the Director's Foreword, especially at the Frick, I am boundlessly grateful to Giuseppe Penone for welcoming me to his studio, to Pepi Marchetti Franchi for spearheading this project, and to Ruggero Penone for following it every step of the way.

This essay is deeply informed by the work of a number of scholars who are mentioned here, the notes being confined to direct quotations. A good account of the history of porcelain is De Waal 2015. For a more scholarly perspective, see Finlay 2010. For Sèvres porcelain, in particular, the best reference remains Brunet and Préaud 1978. For twentieth-century artists at the Sèvres Porcelain Manufactory, see Midant 1992; while for twentieth-century ceramics more broadly, see De Waal 2003. For the dialogue between large- and small-scale porcelain at Sèvres, see Sèvres 2005–6; but for a more scholarly perspective, see Carey 2008.

The literature on Penone's work is vast. The recent multi-volume monographic work by Basualdo (2018) spans the entirety of the artist's career and should be read in conjunction with Penone's own collected writings (Maraniello and Watkins 2009, which is published in both Italian and English versions). Other exhibition catalogues, books, and articles that have proven especially useful in this study are Penone 1977; Celant 1989; Rivoli 1991–92; Nîmes, Tilburg, and Trent 1997–98; Didi-Huberman 2000; New York and Milton Keynes 2004; Paris and Barcelona 2004–5; Rome 2008; Busine 2012; Grenoble 2014–15; Lausanne 2015–16; Rovereto 2016; Rome 2017; Guzzetti and Penone 2020; Settis 2020, 187–231 (also available in an English translation with minor changes in Basualdo 2018, 145–67); and Florence 2021.

On Arte Povera, the best references are Celant 1969 and Christov-Bakargiev 1999. The best monograph on Piero Manzoni is Grazioli 2007 (for the artist's relationship with Albisola, see Pola 2013). Regarding the image/index problem, Penone literature can be read against the backdrop of Krauss 1977. For Mellan, in general, see Paris 1988; Rome 1989–90; Cropper 1990; and Zorach 2009. On the *Face of Christ*, see Lavin 2006 and Turel 2011. On the intelligence of plants, see Hallé 1999; Hallé and Torquebiau 2021; and also Mancuso and Viola 2015. All translations are mine, unless otherwise specified.

1. Woolf 2002, 113.

2. G. Penone in Maraniello and Watkins 2009, 317.

3. Ibid., 58.

4. C. de Zegher in New York and Milton Keynes 2004, 46. For the drawings, see acc. nos. 323.1983 and 325.1983 in the Museum of Modern Art, New York.

5. Property of the artist, reproduced in New York 2021, 3.

6. G. Penone in Maraniello and Watkins 2009, 299.

7. Property of the artist, reproduced in Basualdo 2018, 9 (*Propagazioni*): unpaginated.

8. T. Ingold in Basualdo 2018, 1 (Essays): 62. See also Florence 2021.

9. R. Labrusse in Basualdo 2018, 1 (Essays): 104.

10. C. Basualdo in Basualdo 2018, 1 (Essays): 41.

11. G. Penone in New York and Milton Keynes 2004, 102.

12. Ibid., 37.

13. G. Penone in Maraniello and Watkins 2009, 208.

14. Ibid.

15. Ibid., 226.

16. Ibid., 139.

17. Ibid., 207.

18. Ibid., 197.

19. G. Penone in Basualdo 2018, 1 (Essays): 41.

20. In conversation with the artist, March 4, 2021.

21. C. de Zegher in New York and Milton Keynes 2004, 30.

22. G. Penone in Basualdo 2018, 9 *(Propagazioni)*: unpaginated.

23. Celant 1989, 17.

24. G. Penone in Maraniello and Watkins 2009, 275.

25. G. Penone in New York and Milton Keynes 2004, 50.

26. C. de Zegher in New York and Milton Keynes 2004, 13.

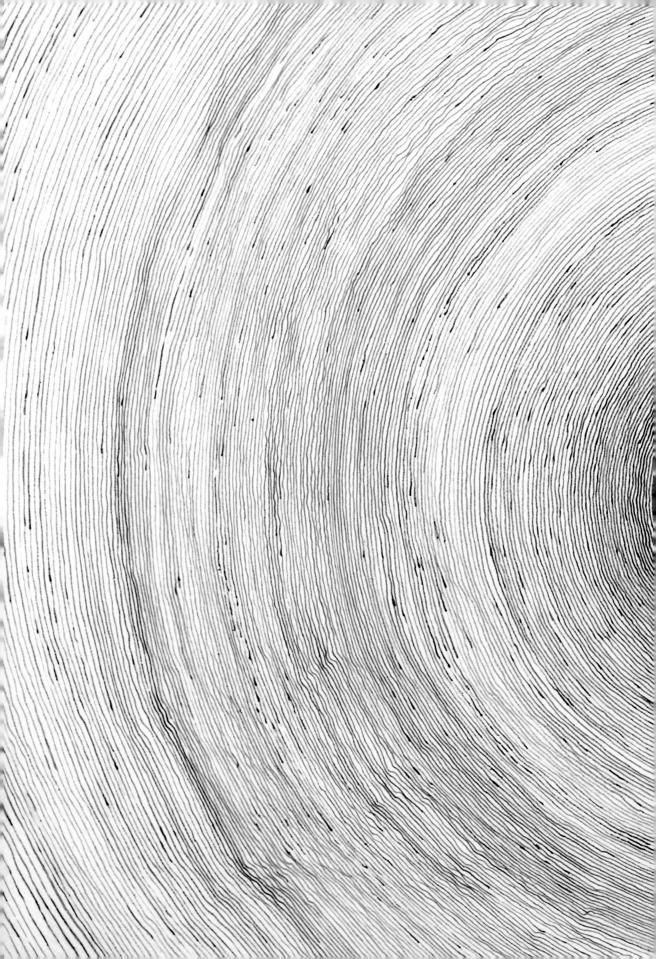

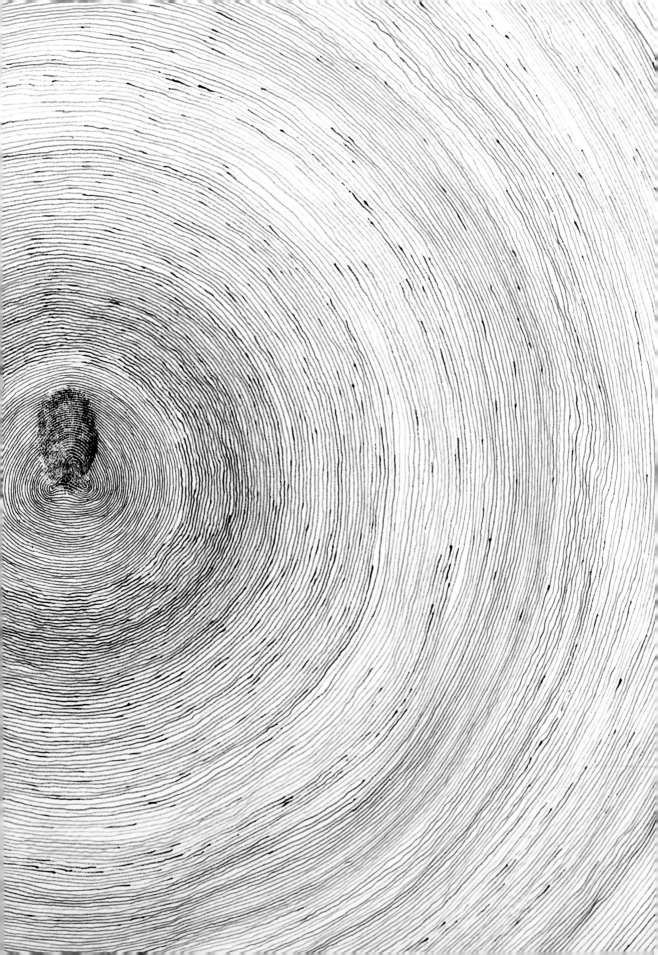

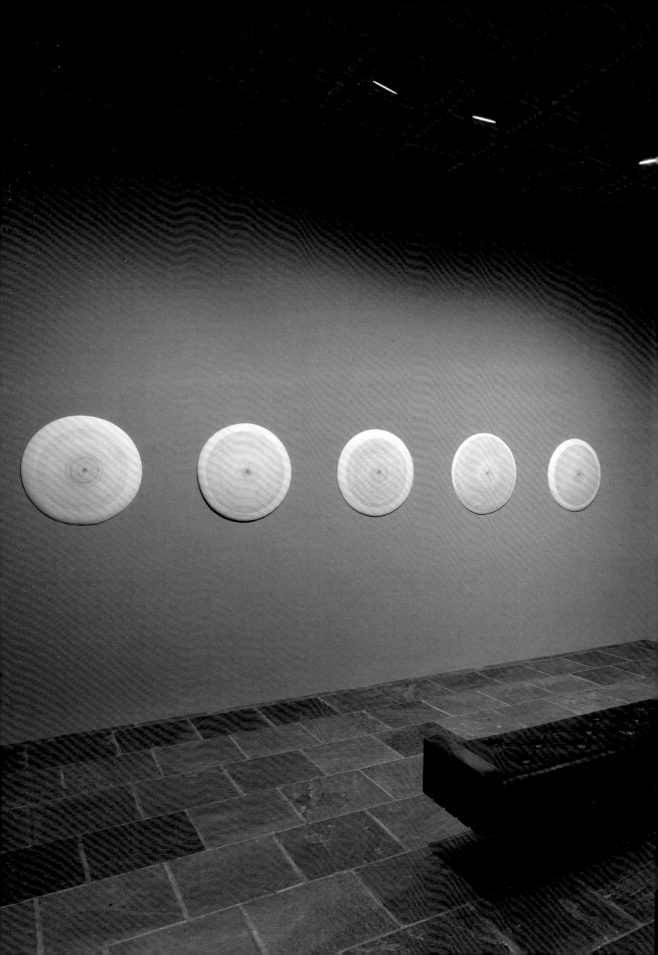

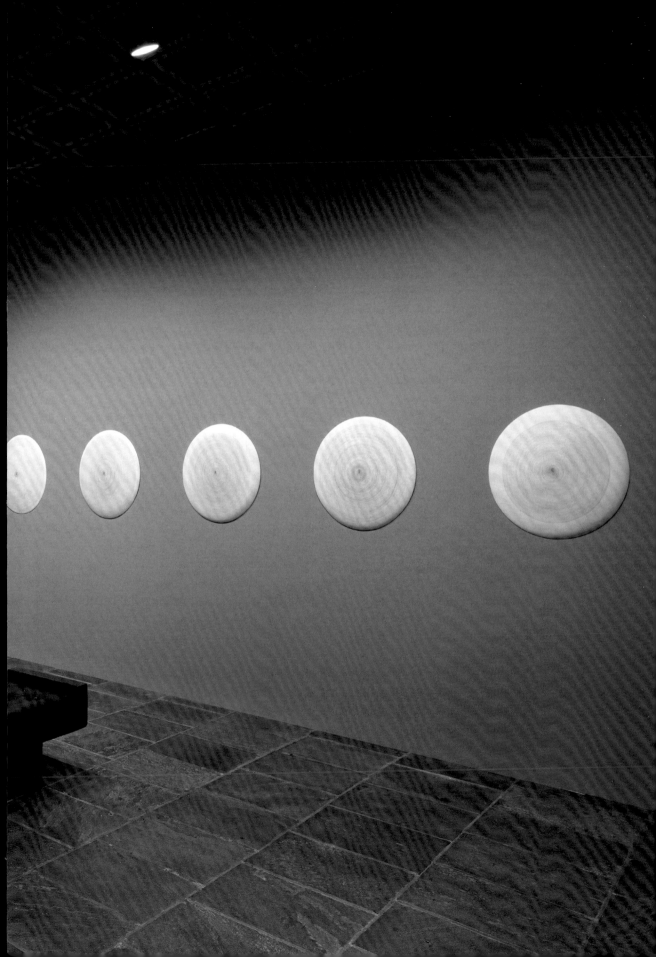

PROPAGAZIONE DI SÈVRES—POLLICE DESTRO
(SÈVRES PROPAGATION—RIGHT THUMB)

2013, metal-oxide paint on Sèvres porcelain, diam. 26 ¾ in. (68 cm), depth 2 ⅜ in. (6 cm). Courtesy the artist

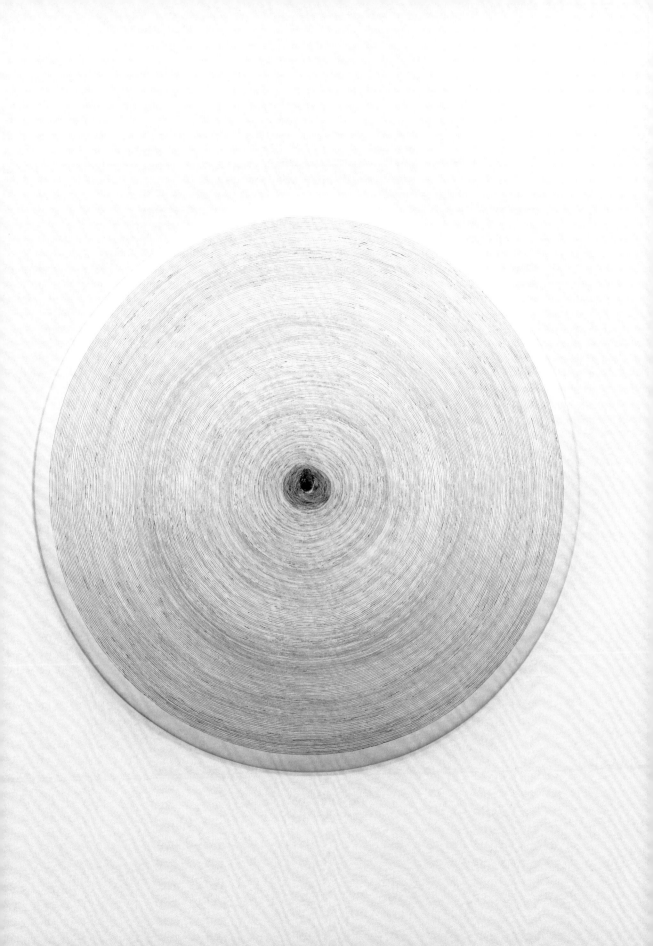

PROPAGAZIONE DI SÈVRES—INDICE DESTRO
(SÈVRES PROPAGATION—RIGHT INDEX FINGER)

2013, metal-oxide paint on Sèvres porcelain, diam. 26 ¾ in. (68 cm), depth 2 ⅜ in. (6 cm). Courtesy the artist

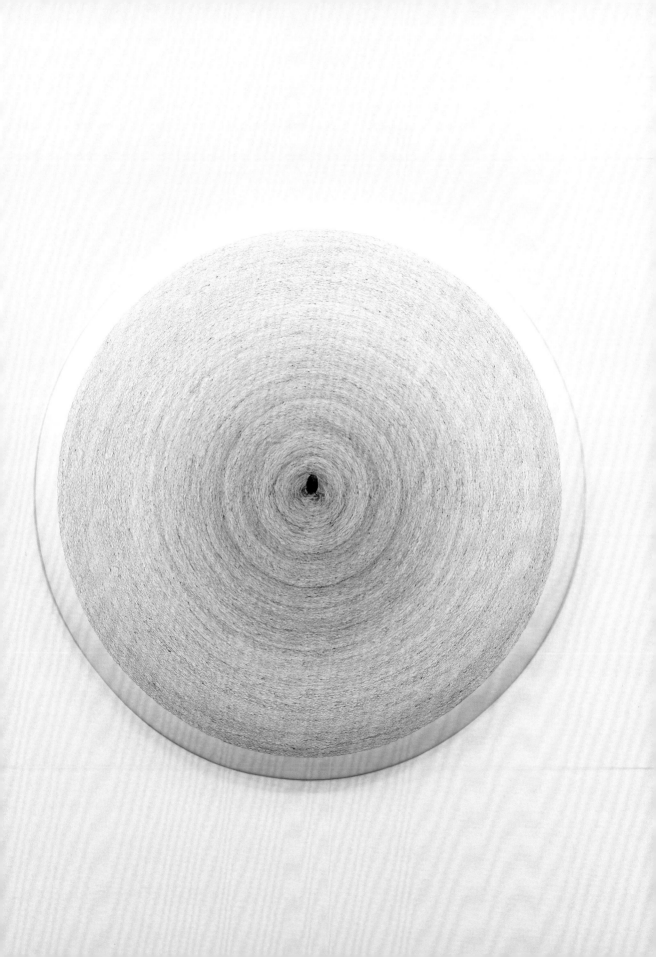

PROPAGAZIONE DI SÈVRES—MEDIO DESTRO
(SÈVRES PROPAGATION—RIGHT MIDDLE FINGER)

2013, metal-oxide paint on Sèvres porcelain, diam. 26¾ in. (68 cm), depth 2⅜ in. (6 cm). Courtesy the artist

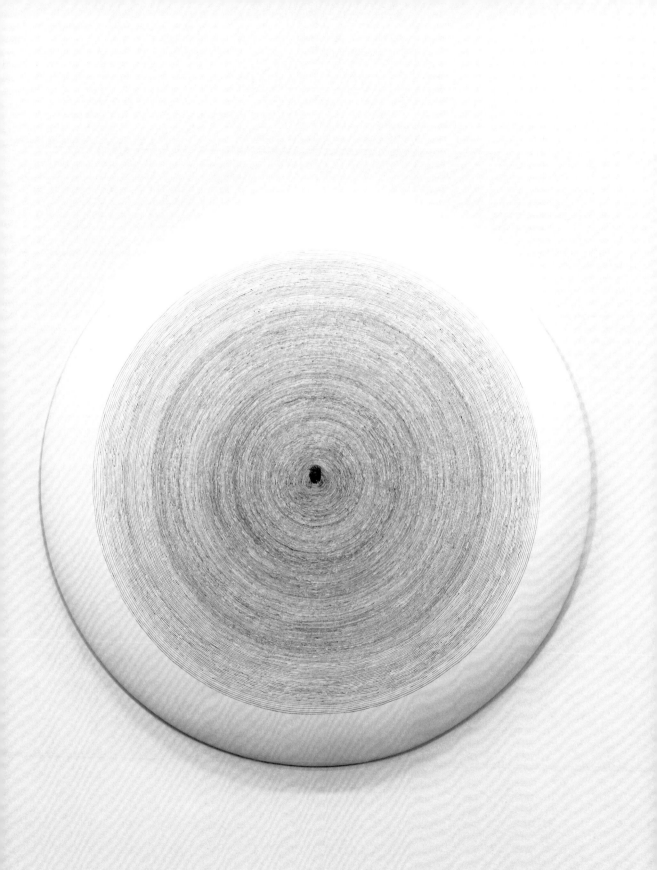

PROPAGAZIONE DI SÈVRES—ANULARE DESTRO
(SÈVRES PROPAGATION—RIGHT RING FINGER)

2013, metal-oxide paint on Sèvres porcelain, diam. 26 ¾ in. (68 cm), depth 2 ⅜ in. (6 cm). Courtesy the artist

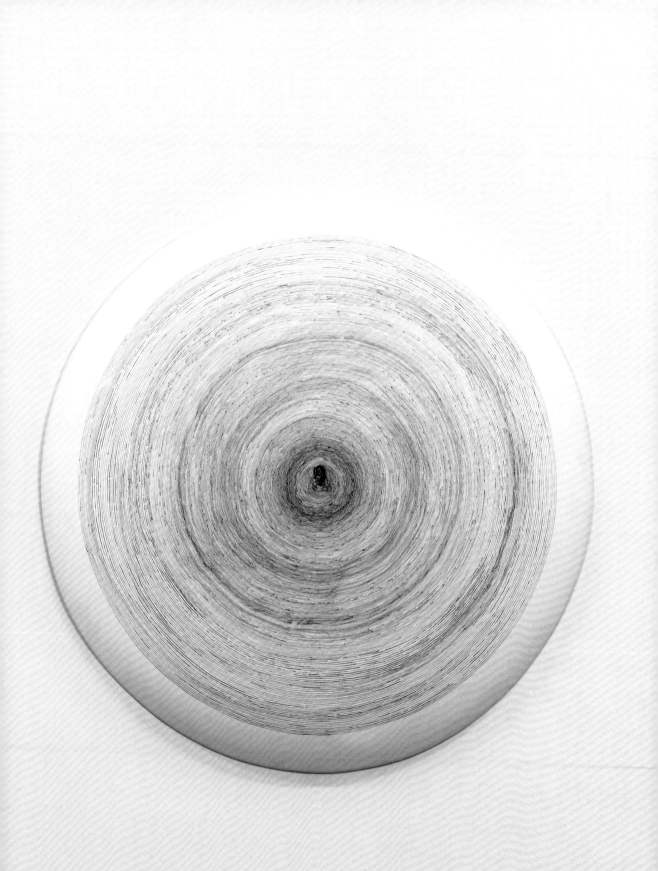

PROPAGAZIONE DI SÈVRES—MIGNOLO DESTRO
(SÈVRES PROPAGATION—RIGHT LITTLE FINGER)

2013, metal-oxide paint on Sèvres porcelain, diam. 26 ¾ in. (68 cm), depth 2 ⅜ in. (6 cm). Courtesy the artist

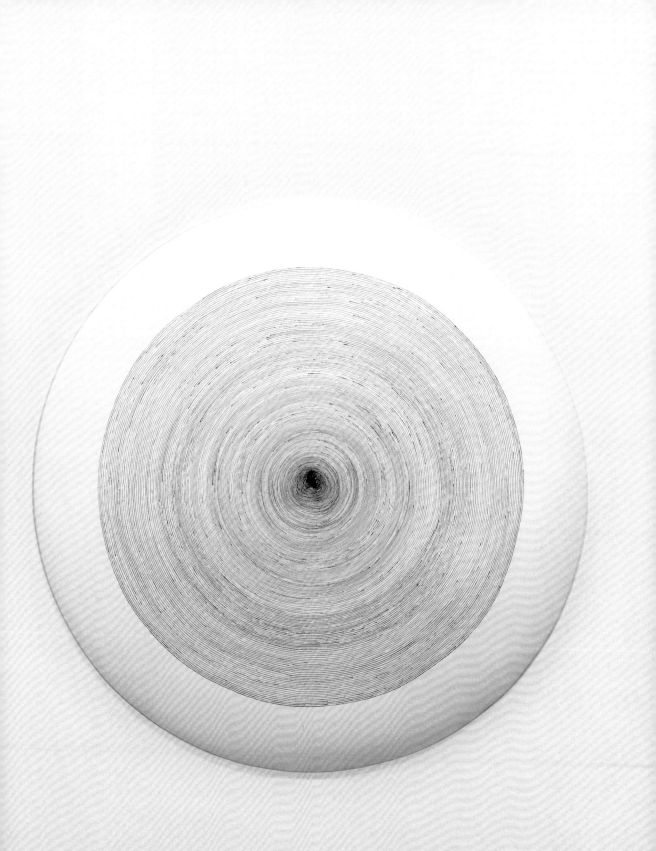

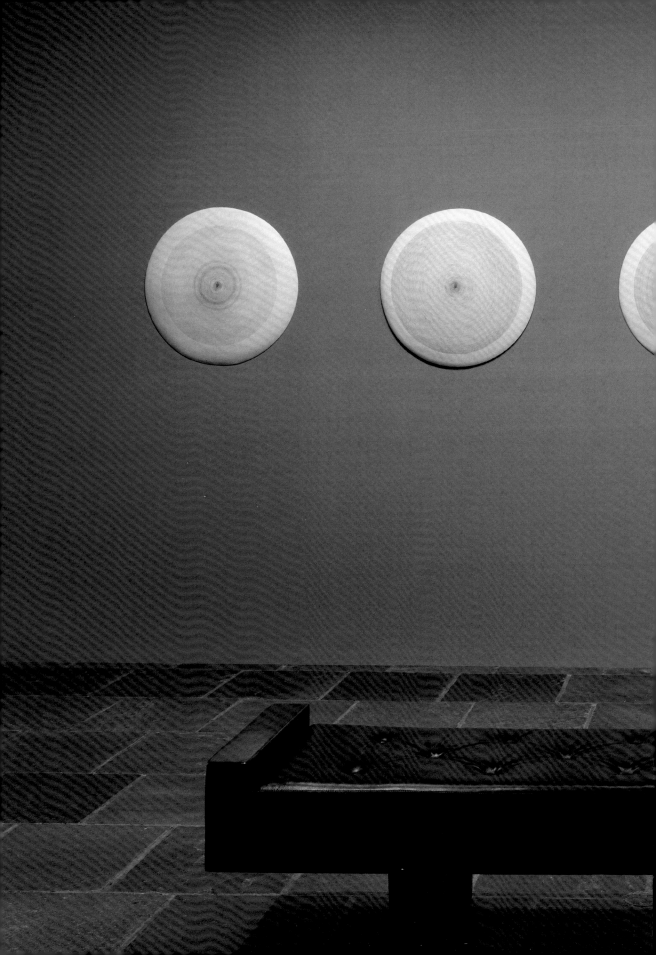

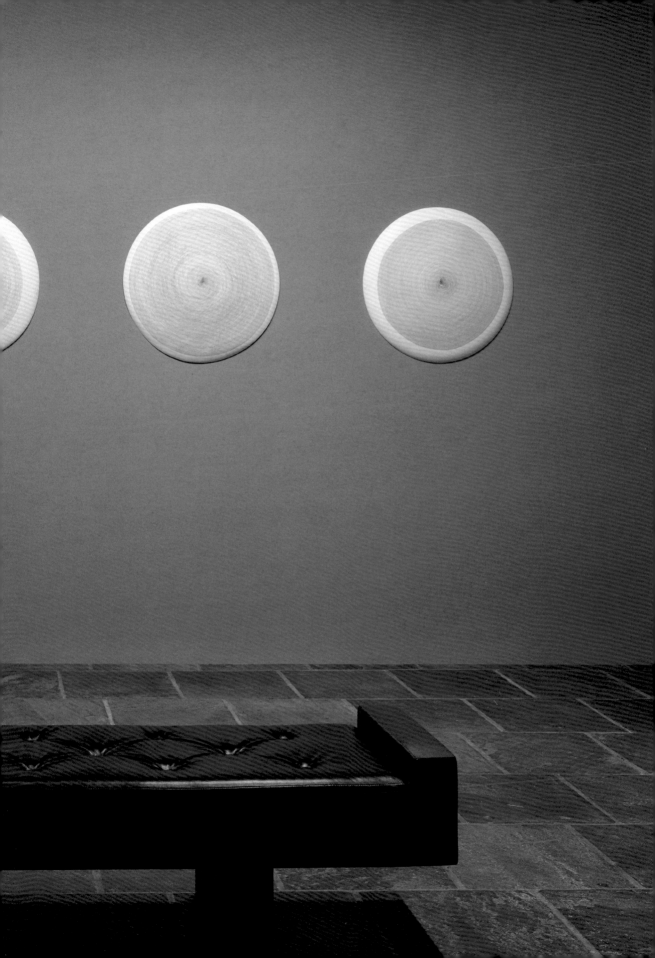

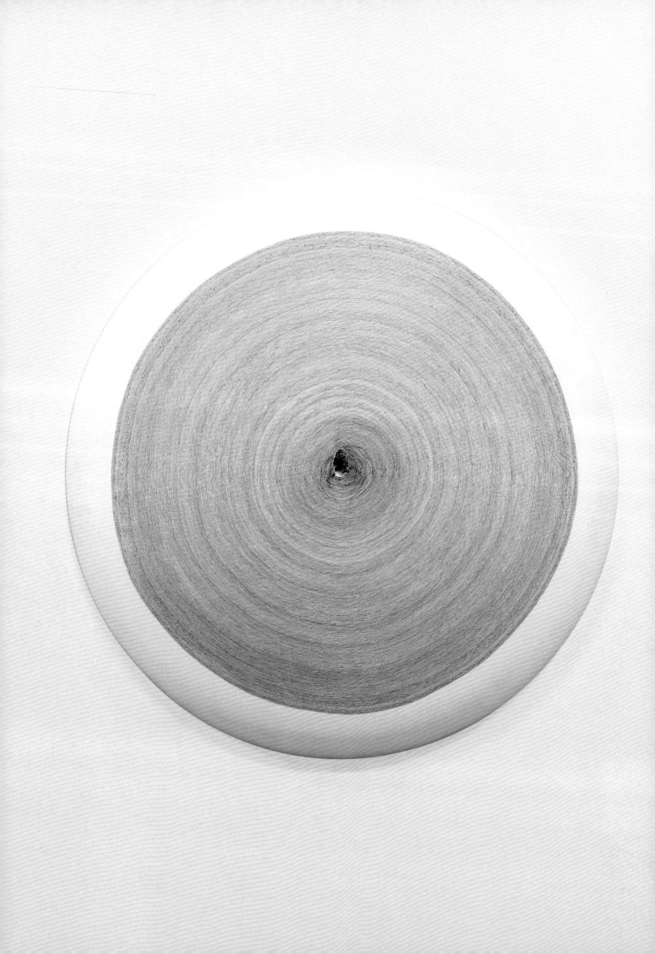

PROPAGAZIONE DI SÈVRES—POLLICE SINISTRO
(SÈVRES PROPAGATION—LEFT THUMB)

2013, metal-oxide paint on Sèvres porcelain, diam. 26 ¾ in. (68 cm), depth 2 ⅜ in. (6 cm). Courtesy the artist

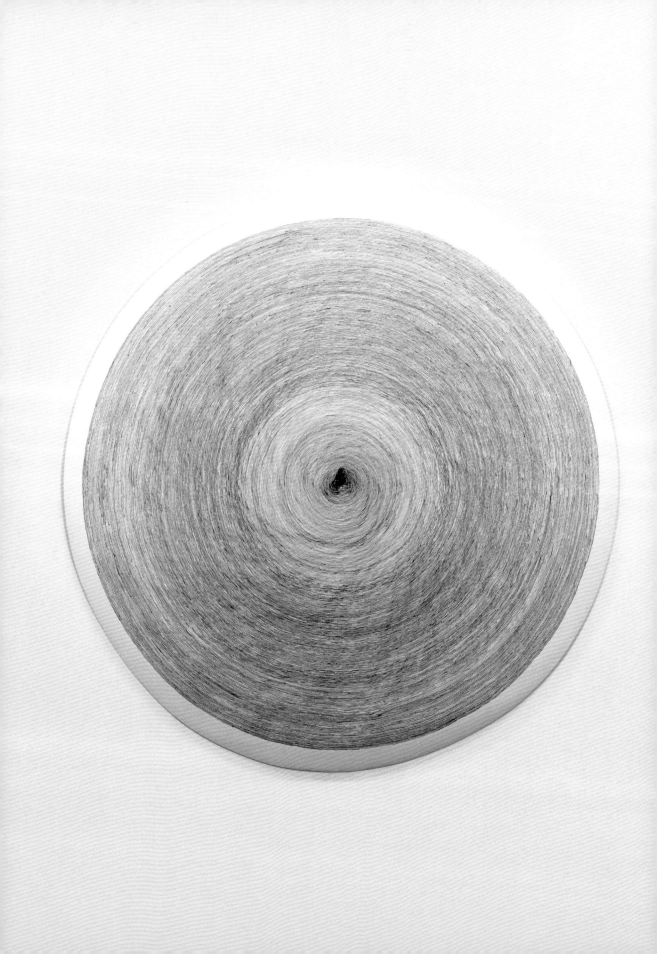

PROPAGAZIONE DI SÈVRES—INDICE SINISTRO
(SÈVRES PROPAGATION—LEFT INDEX FINGER)

2013, metal-oxide paint on Sèvres porcelain, diam. 26 ¾ in. (68 cm), depth 2 ⅜ in. (6 cm). Courtesy the artist

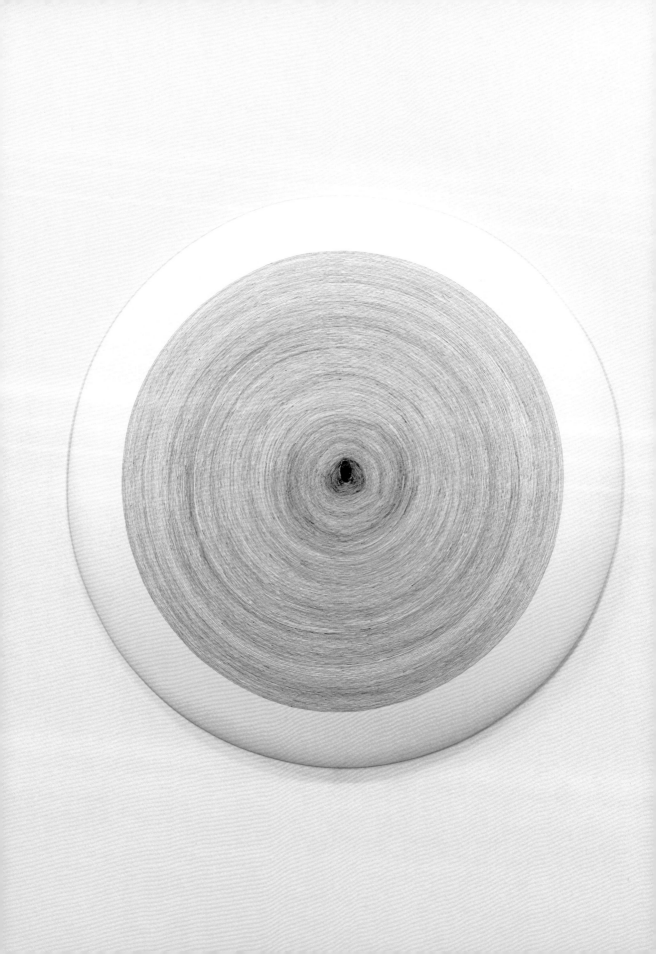

PROPAGAZIONE DI SÈVRES—MEDIO SINISTERO
(SÈVRES PROPAGATION—LEFT MIDDLE FINGER)

2013, metal-oxide paint on Sèvres porcelain, diam. 26¾ in. (68 cm), depth 2⅜ in. (6 cm). Courtesy the artist

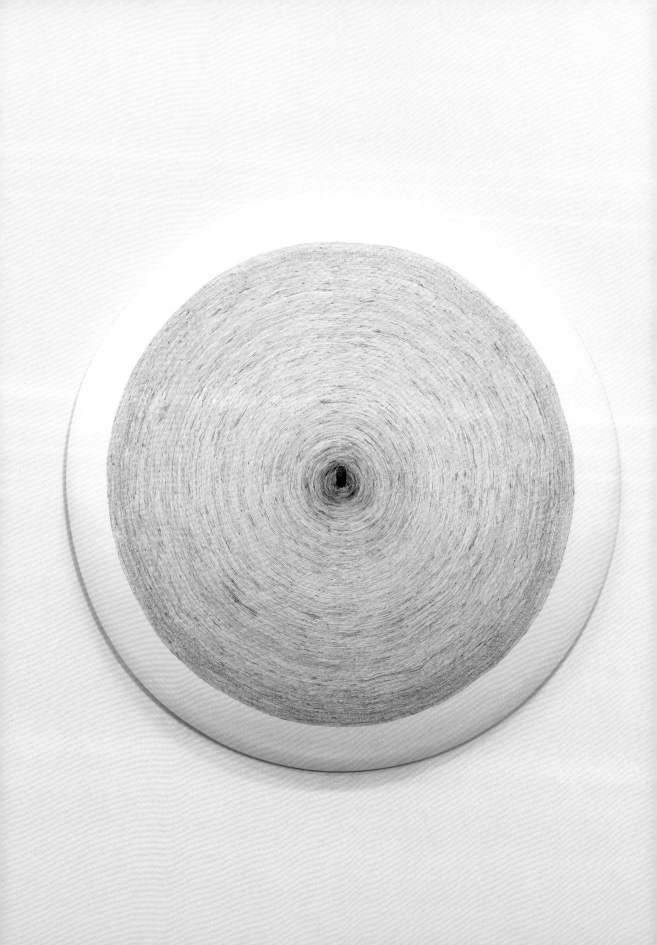

PROPAGAZIONE DI SÈVRES—ANULARE SINISTRO
(SÈVRES PROPAGATION—LEFT RING FINGER)

2013, metal-oxide paint on Sèvres porcelain, diam. 26 ¾ in. (68 cm), depth 2 ⅜ in. (6 cm). Courtesy the artist

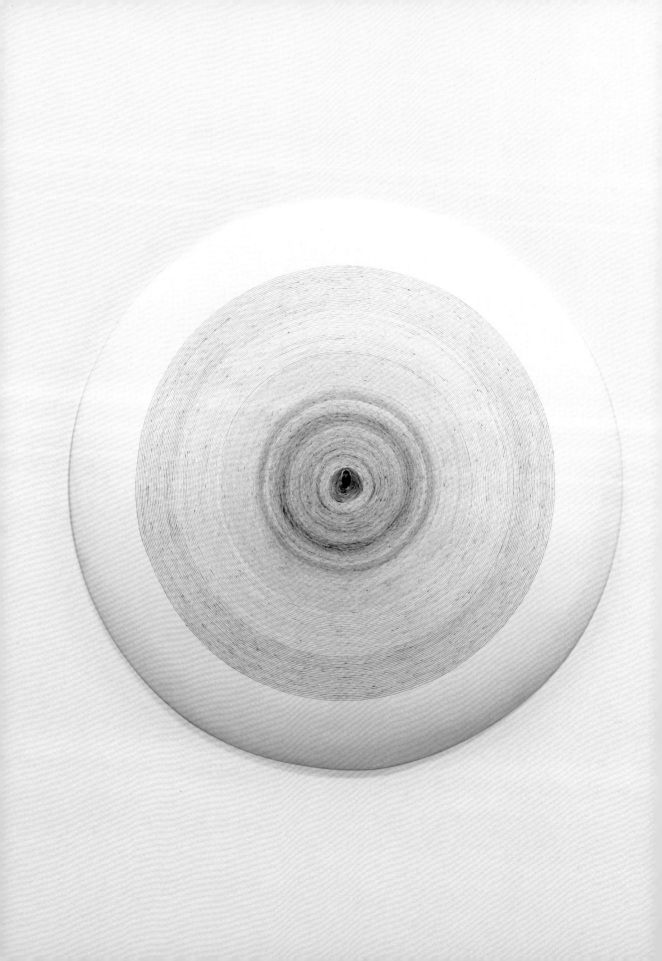

PROPAGAZIONE DI SÈVRES—MIGNOLO SINISTRO
(SÈVRES PROPAGATION—LEFT LITTLE FINGER)

2013, metal-oxide paint on Sèvres porcelain, diam. 26 ¾ in. (68 cm), depth 2 ⅜ in. (6 cm). Courtesy the artist

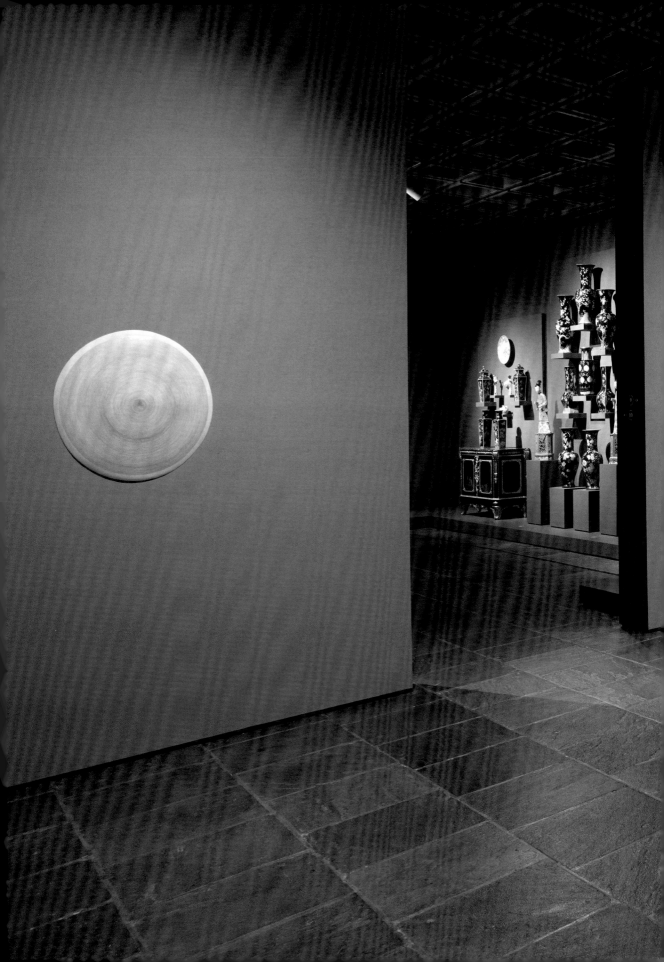

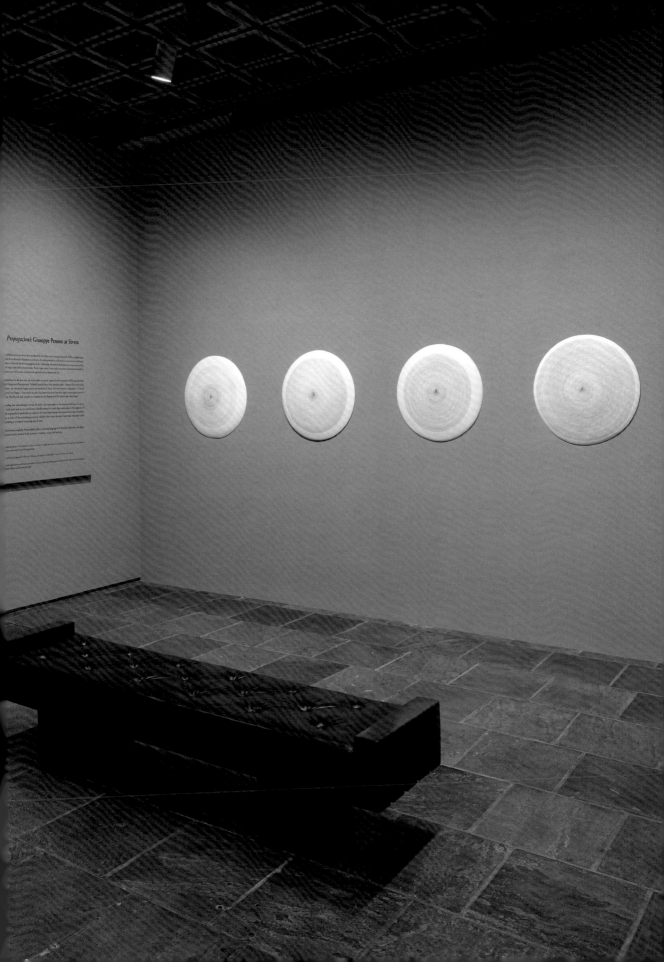

PROPAGAZIONE DI SÈVRES—ORO
(SÈVRES PROPAGATION—GOLD)

2013, gold paint on Sèvres porcelain, diam. 26 ¾ in. (68 cm), depth 2 ⅜ in. (6 cm). Courtesy the artist

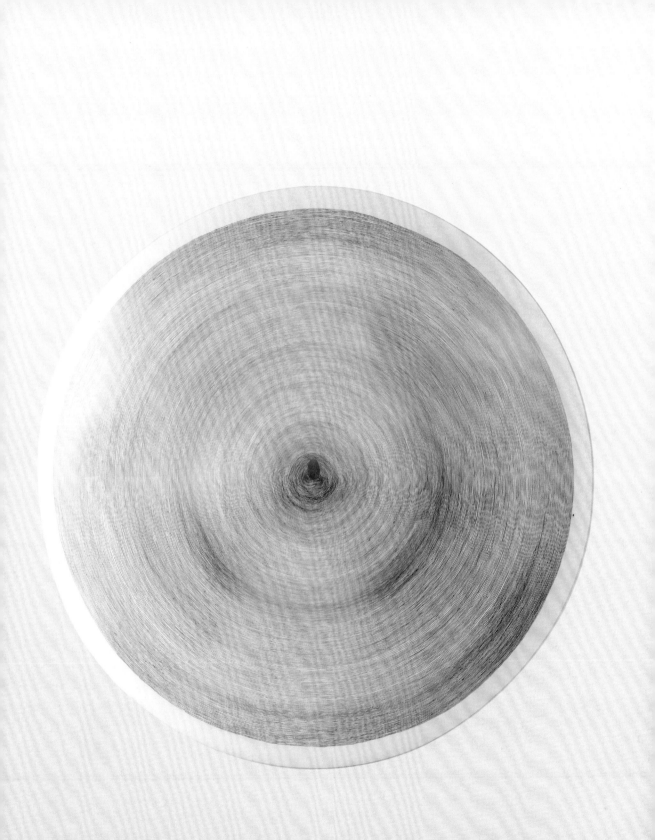

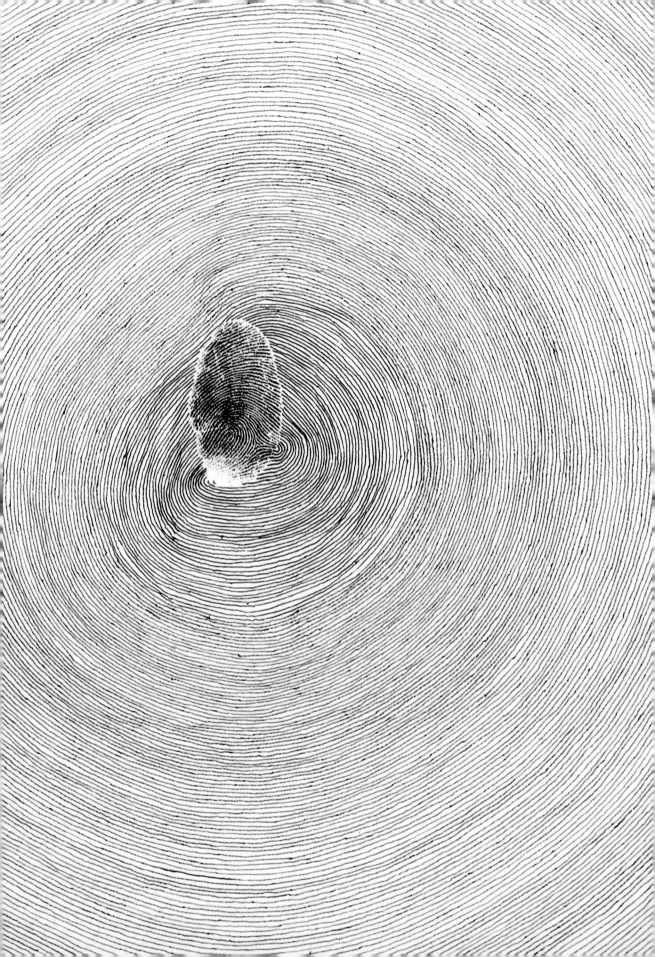

BIBLIOGRAPHY

Basualdo 2018 Basualdo, Carlos, ed. *Giuseppe Penone: The Inner Life of Forms*. 13 vols. New York, 2018.

Brunet and Préaud 1978 Brunet, Marcelle, and Tamara Préaud. *Sèvres: Des origines à nos jours*. Freiburg, 1978.

Busine 2012 Busine, Laurent, et al. *Giuseppe Penone*. Brussels, New Haven, and London, 2012.

Carey 2008 Carey, Juliet. "Aiming High: Porcelain, Sèvres and the Grand Vase." *Art History* 31 (2008): 721–53.

Celant 1969 Celant, Germano. *Arte Povera*. New York, 1969.

Celant 1989 Celant, Germano. *Giuseppe Penone*. Milan, 1989.

Christov-Bakargiev 1999 Christov-Bakargiev, Carolyn, ed. *Arte Povera*. London, 1999.

Cropper 1990 Cropper, Elizabeth. Review of exhibitions: Paris 1988 and Rome 1989–90. *Print Quarterly* 7 (1990): 457–59.

De Waal 2003 De Waal, Edmund. *20th Century Ceramics*. London, 2003.

De Waal 2015 De Waal, Edmund. *The White Road: Journey into an Obsession*. New York, 2015.

Didi-Huberman 2000 Didi-Huberman, Georges. *Être crane: Lieu, contact, pensée, sculpture*. Paris, 2000.

Finlay 2010 Finlay, Robert. *The Pilgrim Art: Cultures of Porcelain in World History*. Berkeley, 2010.

Florence 2021 Gianfranco Maraniello, Carlo Ossola, and Renata Pintus, eds. *Giuseppe Penone: Alberi in versi*. Exh. cat. Florence (Gallerie degli Uffizi), 2021.

Grątkowska-Ratyńska 2009 Grątkowska-Ratyńska, Barbara. "Ikonograficzny zapis wspomnień w dekoracji gerydonu z gabinetu monarchów europejskich." *Kronika Zamkowa* 57–58 (2009): 143–54.

Grazioli 2007 Grazioli, Elio. *Piero Manzoni: In appendice tutti gli scritti dell'artista*. Turin, 2007.

Grenoble 2014–15 Guy Tosatto, ed. *Giuseppe Penone*. Exh. cat. Grenoble (Musée de Grenoble), 2014–15.

Guzzetti and Penone 2020 Guzzetti, Francesco, and Giuseppe Penone. "'A Direct Contact, A Testimony': Drawing as an Investigation of Reality." *Master Drawings* 58 (2020): 517–44.

Hallé 1999 Hallé, Francis. *Éloge de la plante: pour une nouvelle biologie*. Paris, 1999.

Hallé and Torquebiau 2021 Hallé, Francis, and Rozenn Torquebiau. *L'étonnante vie des plantes*. Arles, 2021.

Homer 1990 Homer. *The Iliad*. Translated by Robert Fagles. London, 1990.

Krauss 1977 Krauss, Rosalind. "Notes on the Index: Seventies Art in America." *October* 3 (1977): 68–81; 4 (1977): 58–67.

Kubler 1962 Kubler, George. *The Shape of Time: Remarks on the History of Things*. New Haven, 1962.

Lausanne 2015–16 Bernard Fibicher, ed. *Giuseppe*

71

Penone: Regards croisés. Exh. cat. Lausanne (Musée cantonal des Beaux-Arts), 2015–16.

Lavin 2006 Lavin, Irving. "Il *Volto Santo* di Claude Mellan: *ostendaque etiam quae occultet*." In *L'immagine di Cristo*, edited by Cristoph L. Frommel and Gerhard Wolf, 449–91. Vatican City, 2006.

Madrid 2007 Marie-Laure de Rochebrune, ed. *El gusto "a la griega": Nacimiento del neoclasicismo francés*. Exh. cat. Madrid (Palacio Real), 2007.

Mancuso and Viola 2015 Mancuso, Stefano, and Alessandra Viola. *Verde brillante, sensibilità e intelligenza del mondo vegetale*. Florence, 2015.

Maraniello and Watkins 2009 Maraniello, Gianfranco, and Jonathan Watkins. *Giuseppe Penone. Writings 1968–2008*. Bologna and Birmingham, 2009.

Midant 1992 Midant, Jean Paul. *Sèvres: la manifacture au XXème siècle*. Paris, 1992.

New York 2021 Giuseppe Penone and Laurent Busine, eds. *Giuseppe Penone: Leaves of Grass*. Exh. cat. New York (Marian Goodman Gallery), 2021.

New York and Milton Keynes 2004 Catherine de Zegher, ed. *Giuseppe Penone: The Imprint of Drawing / L'impronta del disegno*. Exh. cat. New York (The Drawing Center) and Milton Keynes (Milton Keynes Gallery), 2004.

Nîmes, Tilburg, and Trent 1997–98 Guy Tosatto, ed. *Giuseppe Penone*. Exh. cat. Nîmes (Carré d'Art - Musée d'Art Contemporain), Tilburg (De Pont Foundation for Contemporary Art), and Trent (Galleria Civica d'Arte Contemporanea), 1997–98.

Paris 1988 Maxime Préaud and Barbara Brejon de Lavergnée, eds. *L'oeil d'or: Claude Mellan (1598–1688)*. Exh. cat. Paris (Bibliothèque Nationale), 1988.

Paris and Barcelona 2004–5 Catherine Grenier and Annalisa Rimmaudo, eds. *Giuseppe Penone*. Exh. cat. Paris (Centre Georges Pompidou) and Barcelona (Fundación La Caixa), 2004–5.

Penone 1977 Penone, Giuseppe. *Rovesciare gli occhi*. Turin, 1977.

Pola 2013 Pola, Francesca. *Una visione internazionale: Piero Manzoni e Albisola*. Milan, 2013.

Polo 2016 Polo, Marco. *The Description of the World*. Translated by Sharon Kinoshita. Indianapolis, 2016.

Pope and Brunet 1974 Pope, John A., and Marcelle Brunet. *The Frick Collection: An Illustrated Catalogue*. Vol. 7, *Porcelains: Oriental and French*. New York, 1974.

Rivoli 1991–92 Giorgio Verzotti and Ida Gianelli, eds. *Giuseppe Penone*. Exh. cat. Rivoli (Castello di Rivoli, Museo d'Arte Contemporanea), 1991–92.

Rochebrune 2002 Rochebrune, Marie-Laure de. *Le guéridon de madame du Barry*. Paris, 2002.

Rome 1989–90 Luigi Ficacci, ed. *Claude Mellan, gli anni romani: un incisore tra Vouet e Bernini*. Exh. cat. Rome (Galleria Nazionale d'Arte Antica, Palazzo Barberini), 1989–90.

Rome 2008 Daniela Lancioni, ed. *Giuseppe Penone*. Exh. cat. Rome (Académie de France à Rome, Villa Medici) 2008.

Rome 2017 Massimiliano Gioni, ed. *Giuseppe Penone: Matrice*. Exh. cat. Rome (Palazzo della Civiltà Italiana), 2017.

Rovereto 2016 Gianfranco Maraniello, ed. *Giuseppe Penone: Scultura*. Exh. cat. Rovereto (MART), 2016.

Settis 2020 Settis, Salvatore. *Incursioni: Arte contemporanea e tradizione*. Milan, 2020

Sèvres 2005–6 Antoinette Faÿ-Hallé, ed. *De l'immense au minuscule: La virtuosité en céramique*. Exh. cat. Sèvres (Musée National de Céramique), 2005–6.

Turel 2011 Turel, Noa. "Living Pictures: Rereading 'au vif', 1350–1550." *Gesta* 50 (2011): 163–82.

Woolf 2002 Woolf, Virginia. *The Years* [1937]. Edited by Jeri Johnson. London, 2002.

Zorach 2009 Zorach, Rebecca. "'A Secret Kind of Charm not to be Expressed or Discerned': On Claude Mellan's Insinuating Lines." *RES: Anthropology and Aesthetics* 55/56 (2009): 235–51.